THEN & NOW

BIRMINGHAM

Stacey,

A peek at our "Birmingham" and its history.

Polly Fryar

THEN & NOW

BIRMINGHAM

J. D. Weeks

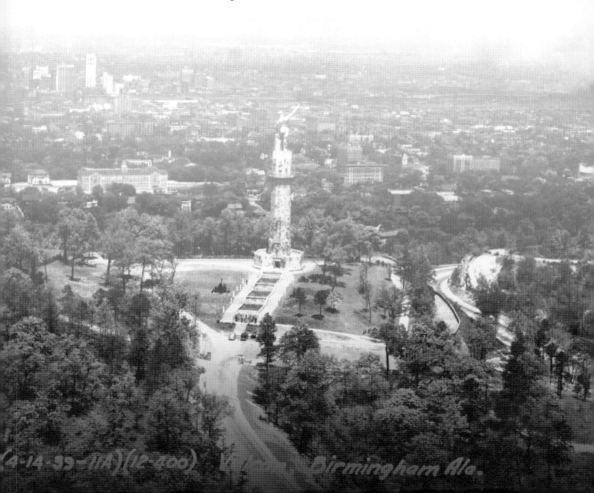

Library of Congress control number: 2006931879

Published by Arcadia Publishing
Charleston SC, Chicago IL, Portsmouth NH, San Francisco CA

Printed in the United States of America

For all general information contact Arcadia Publishing at:
Telephone 843-853-2070
Fax 843-853-0044
E-mail sales@arcadiapublishing.com
For customer service and orders:
Toll-Free 1-888-313-2665

Visit us on the Internet at www.arcadiapublishing.com

This book is dedicated to the loving memory of my precious grandson Stephen Middleton Weeks. We love you very much.

ON THE FRONT COVER: This large gathering in the streets around the Empire Building, *c.* 1918, is there to watch the "human fly" climb to the top of the building. The location is the intersection of First Avenue and Twentieth Street, the heart of the downtown area. Clockwise from the Empire Building (1909) are the Brown-Marx Building (1905), the First National Bank Building (1912), and the Woodward Building (1901). They are all still standing today.

ON THE BACK COVER: The nattily dressed gentlemen in the horse carriage are being pulled by this new 1915 Indian motorcycle to demonstrate the power of the 15-horsepower engine. They are posing in the middle of Twentieth Street, in front of the recently built YMCA building. In the left background can be seen the Molton Hotel and Tutwiler Hotel, both facing Fifth Avenue. On the right side of the street are the Southern Club and the Birmingham Athletic Club. None of these buildings exist today.

CONTENTS

ACKNOWLEDGMENTS

I would first like to thank George Stewart, former director of the Birmingham Public Library, for teaching the History and Development of Birmingham course at the University of Alabama at Birmingham back in 1979. I had already been interested in history, especially local history, and taking that course really focused me, providing the spark I needed. I now have copies of almost every book written about Birmingham history, and I began collecting local memorabilia, eventually starting a collection of vintage Birmingham postcards. Also from the Birmingham Public Library, I am indebted to James Baggett and his staff in the archives department. They have always been very helpful and friendly. All the "then" photographs used in this book came from their large collection of old Birmingham-area photographs.

The postcard views appearing herein came from my personal collection of over 20,000 postcards, which includes over 3,000 different Birmingham-area views. A new experience for me was taking the "now" photographs, which became quite frustrating at times. The trees now lining the streets around town made getting an unobstructed shot, while maintaining the proper angle, almost impossible at times.

We owe much to the early Birmingham photographers, like O. V. Hunt and J. Frank Knox, who created those wonderful photographs that we enjoy today. The postcard publishers, including William Faulkner of the Postcard Exchange in Birmingham, must also be credited for their equally wonderful postcard creations.

Thanks also to my good friend, the late Alvin Hudson, who spent most of his lifetime collecting and taking photographs of Birmingham, when he was not busy researching and writing about the early streetcars of Birmingham.

The outstanding publications of the Birmingham Historical Society and the Jefferson County Historical Commission are indeed invaluable to amateur historians and those of us interested in our early history. Their efforts, and the efforts of other historians and authors, make learning about our past pleasurable.

I am also grateful to my wonderful grandchildren—Jarred Brittian, Christopher Shelnutt, Matthew Shelnutt, James Brittian, Edmund Weeks, Hugh Weeks, Elizabeth Shelnutt, Jonathan Shelnutt, and Richard Weeks, the newest member of my little group, who was born in Moscow, Russia, in 2006. As with my two previous Arcadia books, the grandchildren assisted in choosing the postcard views; however, I made the selection of the early photographs. The thought of that bunch in the archives of the Linn-Henley Research Building was frightening.

This book is dedicated to the loving memory of my precious grandson Stephen Middleton Weeks.

INTRODUCTION

Although Birmingham is in the heart of the Deep South, it is still a very young city. We will explore the changing landscape of this not-so-old "Old South" city during the last 100 years. Industry will be a primary focus, since Birmingham was founded in 1871 at the crossing of two railroads near a vast quantity of coal, iron ore, and limestone, all the minerals needed to make iron. This is the only place on the planet that has all three ingredients in large quantities and close proximity, thus allowing the production of iron and steel without the added costs of transportation to the furnaces, foundries, and mills.

The creation of a new city, with this rich mineral wealth, resulted in the rapid development of an iron and steel industry, with all the accompanying support industries. While steel and iron were the primary products initially, Birmingham soon became a major producer of machinery, such as cotton gins; railroad cars and rails; cast iron, including water and sanitary pipe; cement; brick and clay products; chemicals; lumber; and many others. From 1918 to 1923, the Premocar automobile was produced in Birmingham by the Preston Motor Company. The iron and steel industries alone would earn Birmingham the title of "Pittsburgh of the South." Since the early 1900s, Birmingham has produced most of the cast-iron pipe used in the world. This industrial development required an enormous amount of manpower, and the population quickly grew, so much in fact that it acquired another name—the "Magic City."

In 1904, Birmingham wanted an exhibit at the St. Louis World's Fair, actually the Louisiana Purchase Exposition, which would showcase the mineral wealth of the region. It was decided to build a 56-foot-tall statue made of iron from Red Mountain ore and cast in Birmingham. Made in the likeness of Vulcan, the mythical Roman god of fire and forge, it was a great success and won a grand prize, as well as a gold medal for Guiseppe Moretti, the Italian sculptor. After the exposition, offers to purchase the huge iron statue came from the cities of St. Louis and San Francisco, but they were declined. *Vulcan* returned to Birmingham and, after spending over 30 years at the Alabama State Fairgrounds, was finally erected in 1939 on Red Mountain, from whence he sprang over 100 years ago. He still stands proudly overlooking the city of Birmingham in newly renovated Vulcan Park.

By the middle of the 1970s, Birmingham had begun moving away from its industrial beginnings. This was in part because of the growth and influence of the University of Alabama at Birmingham (UAB) in medicine, medical research, health care, and education. Since UAB appeared on the scene in the 1960s, it has grown to encompass 82 blocks, and there has not been a time since when a construction tower crane was not piercing the sky on the Southside. Birmingham has been a regional banking power for some years, and the recent merger of Regions Bank and AmSouth Bank into Regions Financial will make it one of the top 10 banks in the nation. A thriving service and business economy was also developing. Now Birmingham has become somewhat of a cosmopolitan city but with a Southern accent. Recently Birmingham was proclaimed "America's Most Livable

City" by the U.S. Conference of Mayors and by *Newsweek* magazine as "One of America's Top 10 Cities" in which to live.

The people of Birmingham are quite diverse and have a rich heritage in many areas, including music, sports, and entertainment. From the movie, television, and entertainment industry, we have Kate Jackson, Nell Carter, Courteney Cox, Fannie Flagg, Wayne Rogers, and Louise Fletcher. And do not forget our American Idol winners, Ruben Studdard in 2003 and Taylor Hicks in 2006. Bo Bice placed second in 2005 and Diana DeGarmo, who was born in Birmingham but now lives in Georgia, placed second in 2004. Recently thousands of people from around the country came to Birmingham to audition for the 2007 American Idol, perhaps hoping that some of the magic in the Magic City would rub off on them. From the music business we have from Birmingham the Temptations, Emmy Lou Harris, Lionel Hampton, Eddie Kendricks, and Dinah Washington. Our most recent Miss America winners were Deidre Downs (2005) and Heather Whitestone (1995). Condoleezza Rice, currently secretary of state; Howell Raines, former editor of the *New York Times*; and Walker Percy, noted author, are all from Birmingham. From the sports world, there are many from Birmingham, but we only have space to name a few. Pat Sullivan and Bo Jackson, both Heisman trophy winners, represent football along with Bobby Bowden, coach at Florida State University and the current holder of the most wins in college football. There is Charles Barkley representing basketball, Carl Lewis for track, and Willie Mays for baseball. From golf, we have Hubert Green and the world champion blind golfer, Charlie Boswell. From NASCAR, there are Bobby and Davey Allison and Neil Bonnett. And for good measure, throw in Mel Allen, one of the greatest sportscasters ever.

The landscape of the City Center and Southside is undergoing great change. Many older buildings, both large and small, are being renovated and converted to loft living space. Some of the two- and three-story buildings downtown have been converted to private residences or combination residence and business. The City Federal Building, a 27-story structure built in 1913, is undergoing renovation for condominiums, as is the old 20-story Thomas Jefferson Hotel. The Redmont Hotel, built in 1925, is converting its upper two floors into two-bedroom condominiums, the first active hotel in Birmingham to enter the condominium market. New buildings are also being constructed to meet the demand for downtown living. This gentrification is attracting restaurants, retailers, and other cultural options back to the downtown area. Birmingham has more public green space per capita than any other city in the country. Ruffner Mountain Nature Preserve, one of the many parks within the city limits, is larger than Central Park in New York City. And it is easy to get to Birmingham with Interstates 20, 59, and 65 intersecting in the center of the city. At the Amtrak station downtown, the Crescent can take you westward to New Orleans or eastward to New York through Atlanta, Washington, Philadelphia, and other cities in between. The Birmingham International Airport facilitates over 3 million passengers annually with over 160 flights daily. Yes, Birmingham has really changed from the days when the mills, foundries, and factories were belching out smoke and grime right downtown. But without the rich mineral deposits and the two railroads crossing together 135 years ago, perhaps Birmingham would still be just an old cornfield and there would be no city here at all.

CHAPTER

1

DOWNTOWN
BUILDINGS AND
BUSINESSES

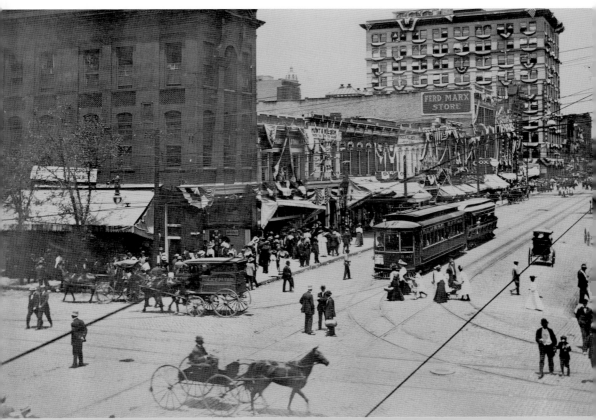

This is a 1908 view of Second Avenue looking east from Nineteenth Street. The flags and bunting are decorations for the 1908 Confederate Veterans Reunion, which was being held in Birmingham. The Peerless Saloon and Billiard Hall was located on the ground floor of the building on the left corner. Perhaps that is where the horse-drawn police patrol wagon, in the lower left foreground, is headed.

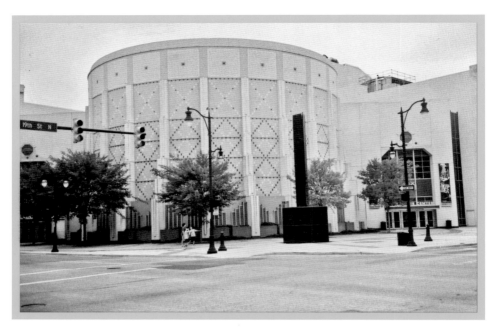

Saks Department Store, operated by Louis Saks and his brothers, was located in this building on the northwest corner of Second Avenue and Nineteenth Street. It was the former site of the Florence Hotel and future site of J. J. Newberry Department Store. On that corner now is the McWane Center—a science center, aquarium, and IMAX dome theater. The old Loveman's Department Store building to the right (see next page) is also part of the complex.

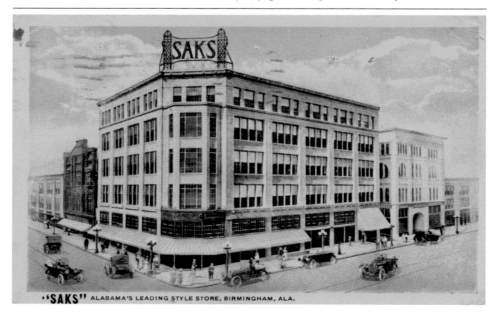

"SAKS" ALABAMA'S LEADING STYLE STORE, BIRMINGHAM, ALA.

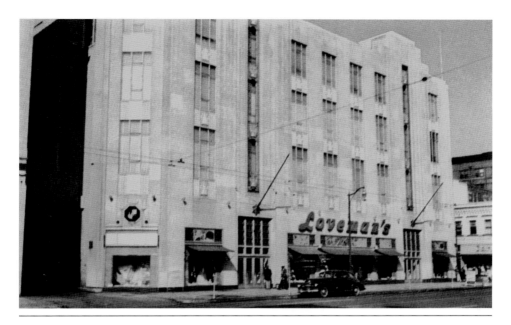

Loveman's Department Store began in 1899 at this location on the southwest corner of Third Avenue and Nineteenth Street. It was originally named Loveman, Joseph, and Loeb after the founders, Moses Joseph, Joseph Loveman, and Leo Loeb. It burned in 1934, and the current building was completed in 1935. Loveman's closed in 1980, and the building now houses part of the McWane Center.

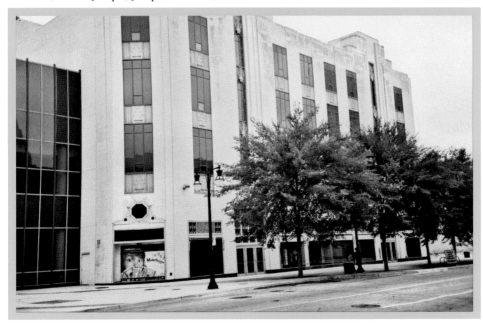

The Nabors-Morrow Building was erected in 1895 at 109 Twentieth Street. When this early-1950s photograph was taken, this was the location of Thompson's Restaurant, owned and operated by John R. Thompson since the 1920s. It later became the home for Charles Arndt's Clothing store, which closed in 1996. In that location since 2003 is Advantage Marketing, a firm specializing in marketing consultation to nonprofits and small businesses. They also publish *Active Culture* magazine.

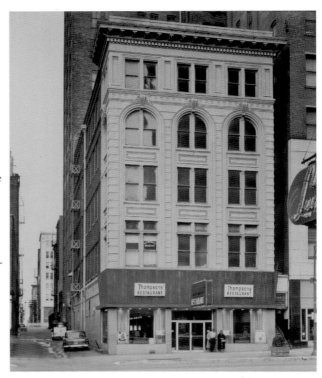

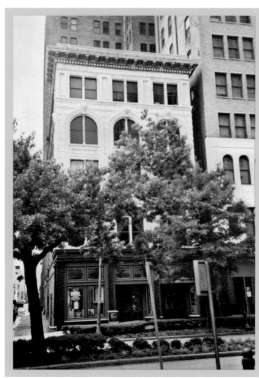

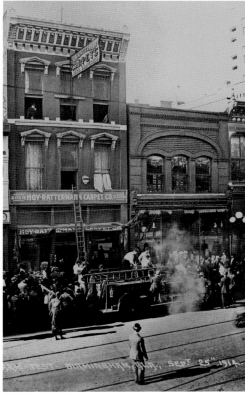

It's September 25, 1914, and there is a fire alarm test going on at the Hoy-Ratterman Carpet Company building, which was located at 2018 Second Avenue. Apparently they are testing the ladders, and the spectators appear to be standing much too close to the action. The building to the right is the John W. O'Neill Company, a dealer in china, glassware, stoves, and home furnishings. All those buildings are now gone, replaced by Birmingham Parking Authority Parking Deck Six, a nine-level public parking facility.

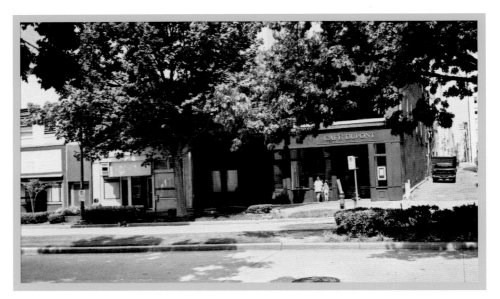

The Two Vests Sign Company was located at 113 Twentieth Street, as seen in this 1925 photograph by O. V. Hunt. Rosania Tailoring was located upstairs. Next door, to the left, is the Joy Young Restaurant, but as their sign in the window indicates, they will soon be moving up the street, where they thrived for over 50 more years. Operating in that building now is the Café Dupont, one of several upscale restaurants that have moved downtown along with the growth of loft apartment living.

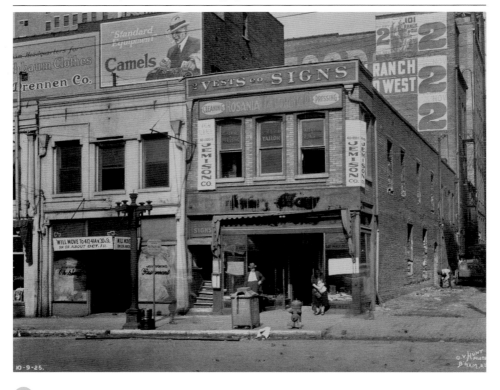

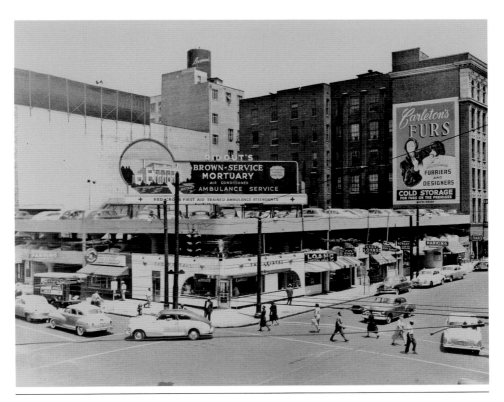

This early-1950s Krystal restaurant was located on the northeast corner of Second Avenue and Eighteenth Street. After a movie at the nearby Alabama Theatre, it was a convenient place to chow down on those little square hamburgers at 10¢ each. And right next door, you could watch and smell those hot Dixie Cream donuts being made. Birmingham's first post office building sat on this corner earlier, and now a parking deck for the McWane Center is located there.

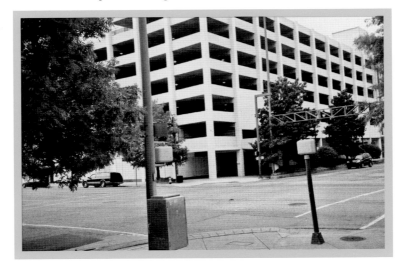

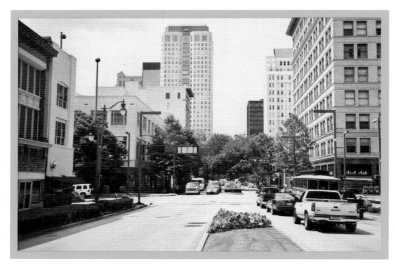

The purpose is not clear for the gathering of all these streetcars at the intersection of Second Avenue and Twentieth Street. This photograph was taken prior to 1892, since mule cars are present and they did not operate after that date.

On the northwest corner is the Roden Building, one of the earlier downtown buildings. Parisian's Department Store moved into another structure on that corner in 1933. It now houses the firm of Hendon and Huckestein Architects.

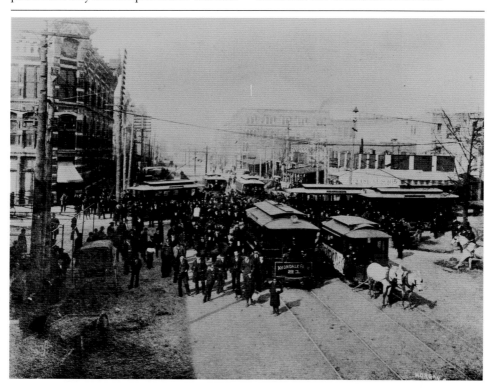

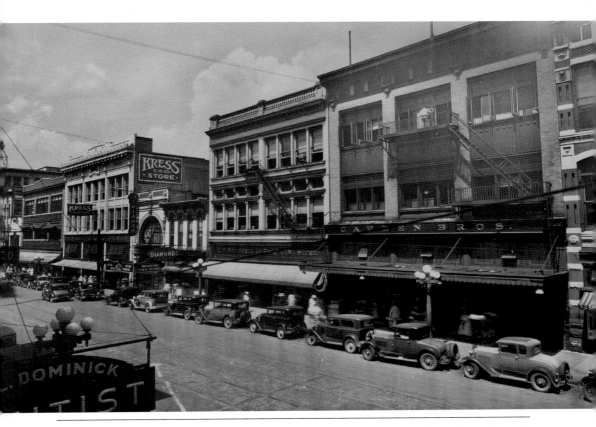

Second Avenue, between Nineteenth and Twentieth Streets, was a busy place, as shown in this early-1930s photograph. The Kress store was at this location from 1915 until they moved to their new Third Avenue store in 1937. The Trianon Theatre was next door to Kress, and across the street were the Odeon, Capitol, Strand, and Galax Theatres. A close look will reveal the Kress sign on the side of their old building. Some of these buildings are currently undergoing renovation.

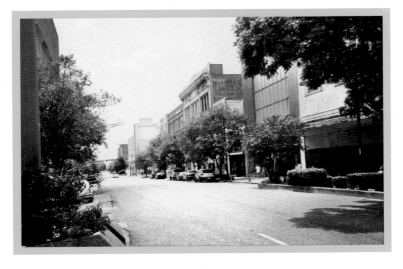

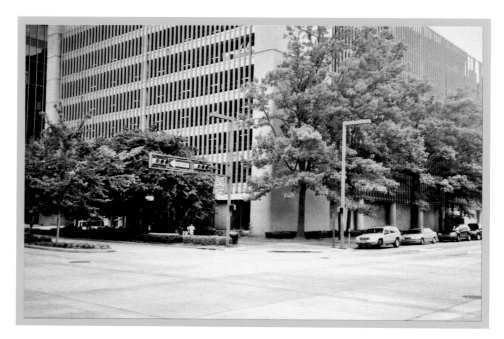

The Central Market operated on the northeast corner of Fourth Avenue and Twentieth Street. In this *c.* 1908 photograph, the Cincinnati Steam Dye Works can be seen up the street to the left. And to the right, up Fourth Avenue, are Alabama Fish and Birmingham Fish. This appears to be the place to go for fresh meat, vegetables, and fish. Now at that location is the Birmingham Parking Authority Headquarters, on the ground floor of one of their nine-level parking facilities.

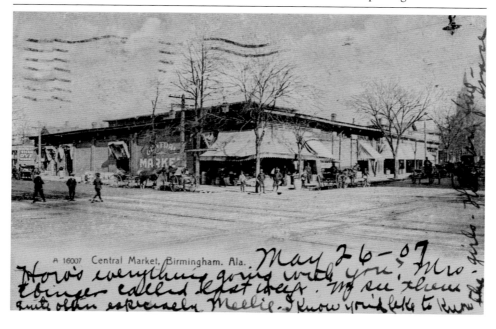

A 16007 Central Market, Birmingham. Ala.

DOWNTOWN BUILDINGS AND BUSINESSES

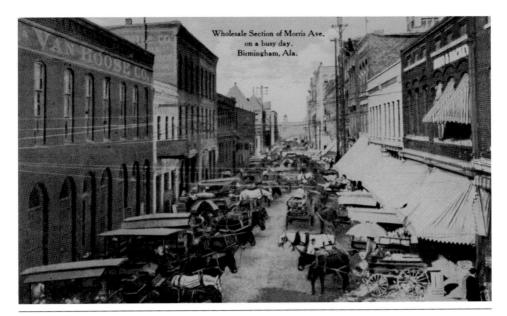

Wholesale Section of Morris Ave.
on a busy day.
Birmingham, Ala.

Birmingham's first wholesale district began developing on Morris Avenue about 1886. Both sides of the street were lined with wholesalers of groceries, fruits, meal, flour, tea, coffee, spices, and other goods. In the 1970s, Morris Avenue was revitalized as an entertainment district and tourist attraction, patterned after Atlanta Underground. These renovated buildings now house offices for lawyers, architects, and other professionals, as well as providing loft living space. Sloss Furnace, an industrial museum since 1983, can be seen in the background of both views.

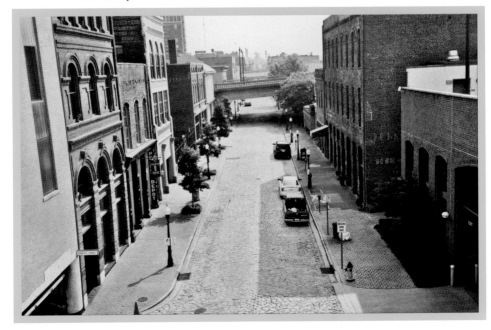

The Molton Hotel, an eight-story structure, was built in 1913 on the northeast corner of Fifth Avenue and Twentieth Street. One of four large hotels built on Fifth Avenue, it was conveniently located only six blocks west of the Terminal Station. Streetcars would bring arriving train passengers down Fifth Avenue, where many choices for lodging were available. The Molton was demolished in 1979, and the headquarters for Compass Bank now sits on that corner.

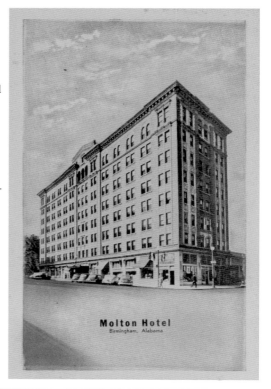

Molton Hotel
Birmingham, Alabama

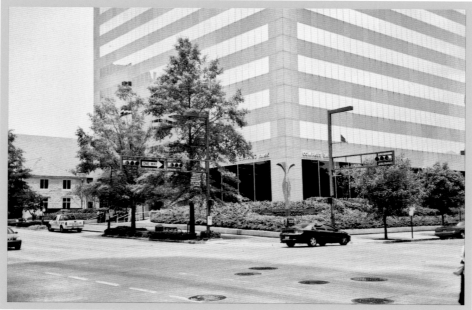

DOWNTOWN BUILDINGS AND BUSINESSES

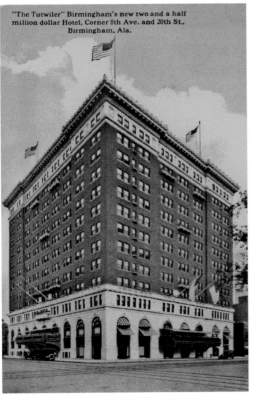

"The Tutwiler" Birmingham's new two and a half million dollar Hotel, Corner 5th Ave. and 20th St., Birmingham, Ala.

The Tutwiler Hotel opened in 1914 on the southeast corner of Fifth Avenue and Twentieth Street. Edward Magruder Tutwiler invested profits received from the sale of coal-mining interests in this new hotel and in the Ridgely Apartments nearby. After operating for 60 years, the Tutwiler Hotel was demolished in 1974. On that corner now is the Regions Financial Corporation headquarters. The recent acquisition of AmSouth Bank will make Regions one of the top 10 banks in the United States.

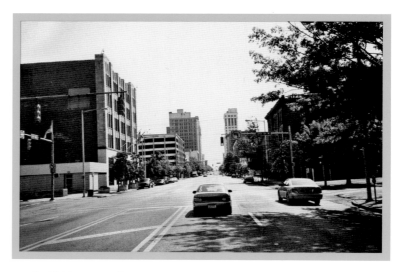

This is an early-1940s view of First Avenue, looking east from Seventeenth Street. This photograph illustrates the wisdom of the early developers of Birmingham, who laid out streets that were 100 feet wide. Even then, streetcars and automobiles were in competition for space on the roadway. Notice the Standard Oil station on the right offered 24-hour Atlas service. In the background of both pictures, you can see the Empire Building on the left and the slim silhouette of the First National Bank building on the right.

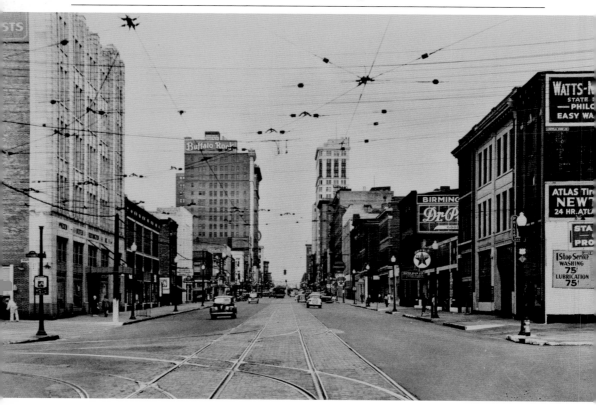

ON THE SOUTHSIDE

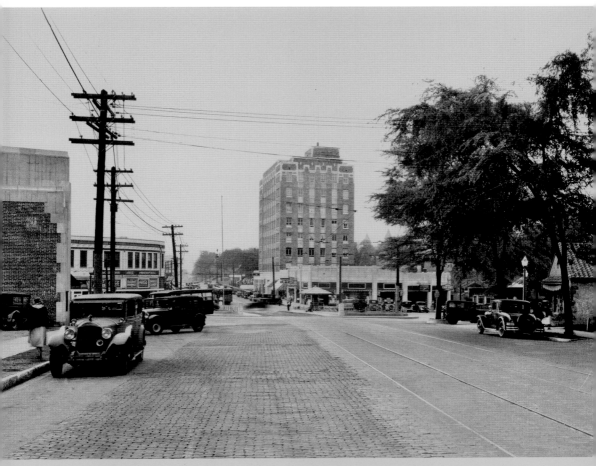

The Five Points South neighborhood was the hub of the Southside of Birmingham, with this intersection of five streets being at the center. The town of Highland began here in 1887 before becoming a part of Birmingham in 1893. This 1932 view is looking north down Twentieth Street towards downtown. The tallest structure in view is the Medical Arts Building, which had opened one year earlier.

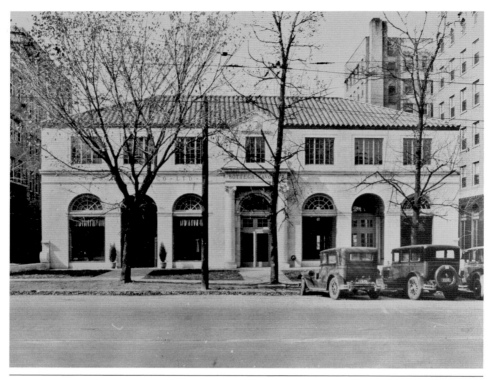

The Bottega Favorita Building was constructed in 1926 for the Gus Meyer Company, an upscale ladies clothing store. Miss Black Florists also shared half the building. Located on Highland Avenue, it was in one of the first exclusive residential areas on the Southside. By the 1960s, it had housed many different kinds of businesses, and at one time, the east side of the building was the headquarters for the Birmingham Area Boy Scouts. The Bottega Café and the Bottega Italian Restaurant are now located there.

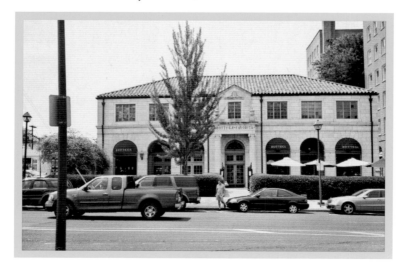

In 1908, the Five Points Grocery was located at 1023 Twentieth Street. By the 1920s, Five Points Grocery had moved across the street and Mayberger's Variety Store had moved into that building. In 1931, the Medical Arts Building was constructed on that site. It was built to house doctors, dentists, and other health care providers (see page 25). It now is the Pickwick Hotel and Suites, named for a popular night club of the 1940s and 1950s that was located around the corner.

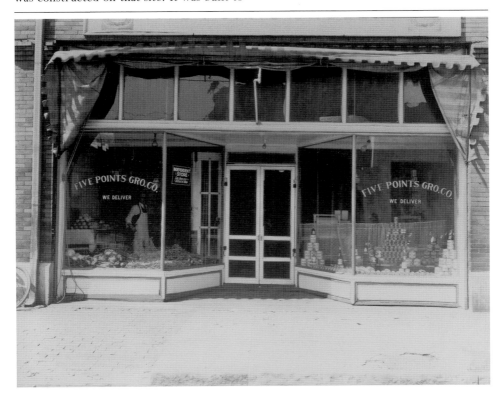

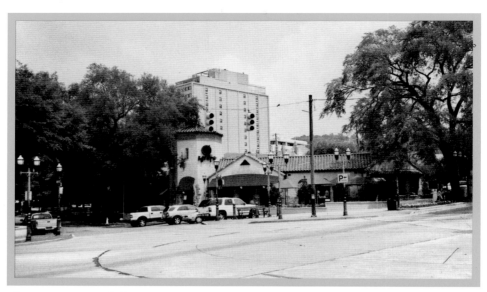

This 1920s view of the Five Points South intersection looking east shows, from left to right, the Exchange Bank, Peerless Laundry, and post office. The Exchange Bank would eventually become Exchange-Security, First Alabama, and finally Regions Bank (see page 23). The Grape, a wine bar and restaurant, is now located in the tall towered structure, which was the Exchange Bank, and also includes the building to the right, which had been the old Peerless Laundry. Farther over to the right is Soca Clothing, and to the far left is Chez FonFon Restaurant.

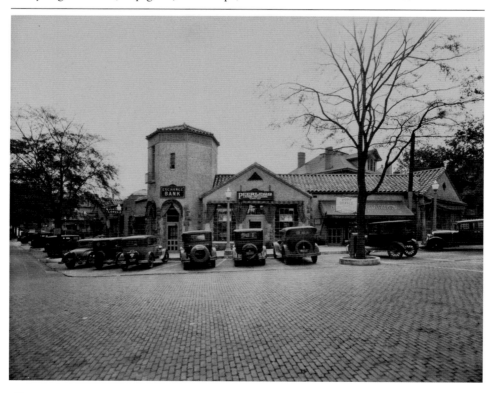

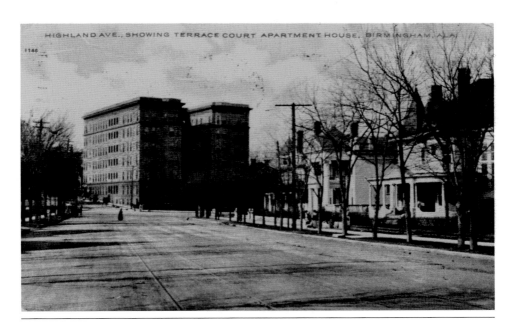

The Terrace Court Apartments, in the background, marked the beginning of Highland Avenue at Twentieth Street. Some of those large fine homes on the right are still standing almost a century later, although most have been converted into offices and businesses. What once was the beginning of an exclusive residential area many years ago is now a thriving mixed-use neighborhood consisting of restaurants, night clubs, apartments, galleries, hardware stores, and offices for doctors, dentists, opticians, and others.

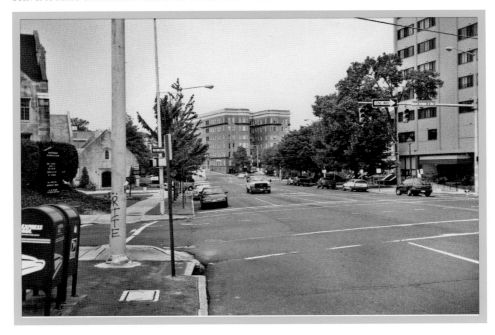

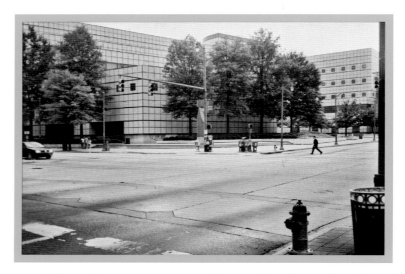

The American Bakeries Company, as seen in this 1930s view, was located on the northeast corner of Twentieth Street and Sixth Avenue, on the Southside. They made Merita bread at that location and also had a plant a half mile to the west where they made crackers. The aroma of the baking bread filled the air all across the Southside. The Kirklin Clinic now sits on that block, and this is the front view of that building (see page 47 for rear view).

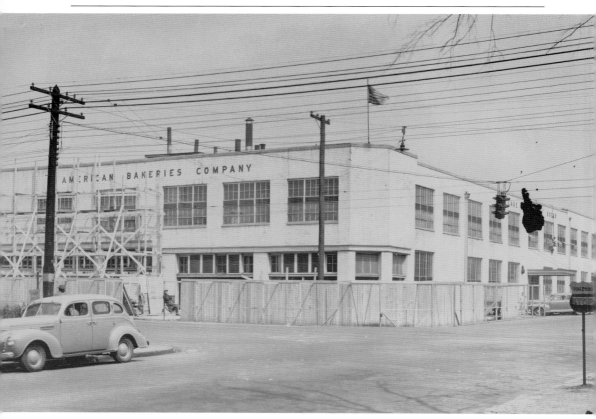

39

11TH AVE WEST FROM 18TH STR., BIRMINGHAM. ALA.

MADE EXPRESSLY FOR R. D BURNETT CIGAR CO.

When the photograph was made for this postcard view of Eleventh Avenue, this was a residential area. The streets are dirt, and streetcar tracks lead to the Five Points intersection two blocks away to the rear. This area of Southside is now a part of the 82-block campus of the University of Alabama at Birmingham, known as UAB. It also includes the Schools of Medicine, Dentistry, Optometry, and Nursing, and many excellent graduate programs. With nearly 19,000 faculty and staff, it is also Birmingham's largest single employer.

Both of these buildings on First Avenue South were operated by two famous "madams" in the early 1900s: Blanche Barnard on the left and "Old Lady Barfield" on the right. The one on the right (2221) was an isolation hospital in the 1920s and had many other uses until becoming the Norburn Apartments in the 1980s. That building is now gone. The one on the left had been the Southern Testing Laboratories from the 1920s until the 1980s and is now Jackson Galleries. Between those concrete walls in the foreground were some early railroad tracks.

CHAPTER 3

CHURCHES, HOSPITALS, AND MEDICAL FACILITIES

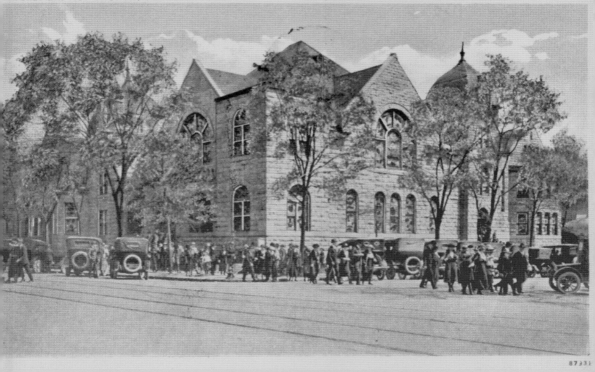

FIRST BAPTIST CHURCH, CORNER 6TH AVE. AND 22ND STREET, NORTH, BIRMINGHAM, ALA.

87331

The First Baptist Church of Birmingham was constructed on the southeast corner of Sixth Avenue and Twenty-second Street in the early 1880s. It was the first Baptist church to build in the city of Birmingham. Some members broke away to form another church on the Southside in 1884 (see page 35). First Baptist Church is now located on Lakeshore Drive near Samford University.

St. Paul's Catholic Church began as a mission church sponsored by St. John's in Tuscaloosa. The first services were held on October 18, 1871, in a two-room log cabin that belonged to Michael Cahalan. A wooden building, facing Twenty-second Street next to the alley, was constructed on the east side of the block in June 1872. The current building, seen here facing Third Avenue, was completed in 1890. Now 116 years later, St. Paul's is a cathedral and still an impressive structure.

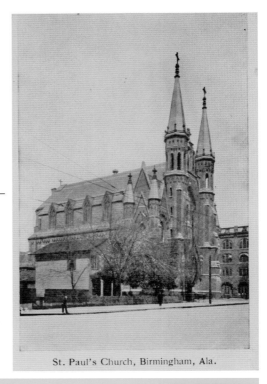

St. Paul's Church, Birmingham, Ala.

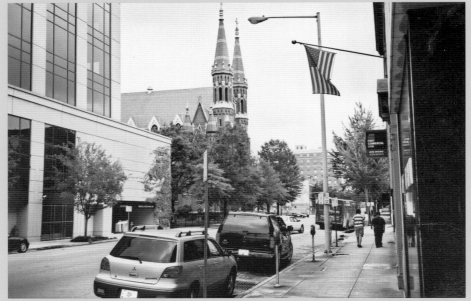

CHURCHES, HOSPITALS, AND MEDICAL FACILITIES

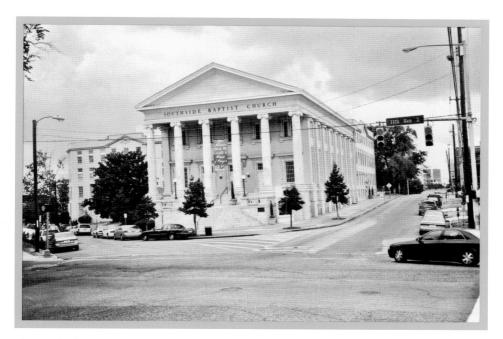

The Southside Baptist Church held services in this new building for the first time on June 28, 1908. Earlier in the morning, after Sunday school services were conducted in their old location, the congregation marched about a half mile to the new church. The property had previously been the site of the Kettig and Walstrom residences. Situated on the northwest corner of Highland Avenue and Nineteenth Street, it is still a beautiful building.

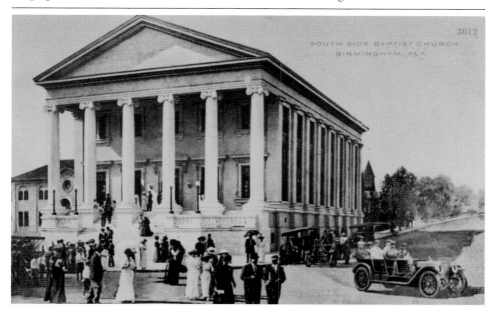

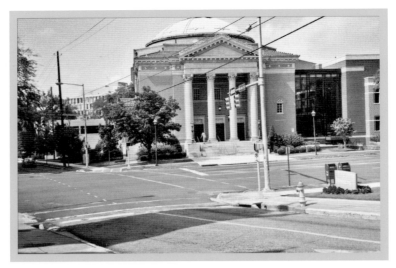

Temple Emanu-El Reform was first located downtown at Fifth Avenue and Seventeenth Street in 1889. This current building was completed and opened in 1913 on Highland Avenue, on the Southside just a few blocks from the Five Points intersection. While waiting for their new temple to be completed, they conducted services in the nearby Southside Baptist Church. Morris Newfield was the rabbi from 1895 to 1940. Large modern additions have been made, but the main part of the structure maintains its original beauty and style.

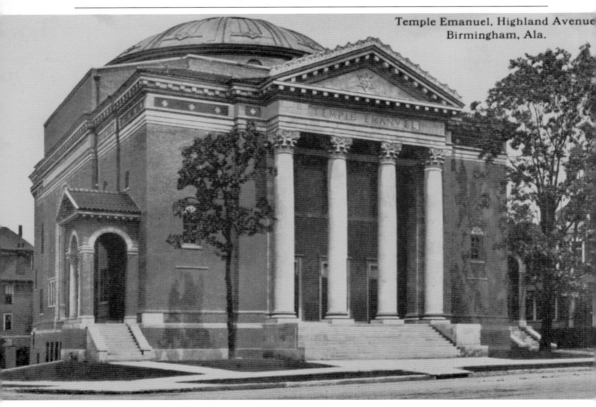

Temple Emanuel, Highland Avenue
Birmingham, Ala.

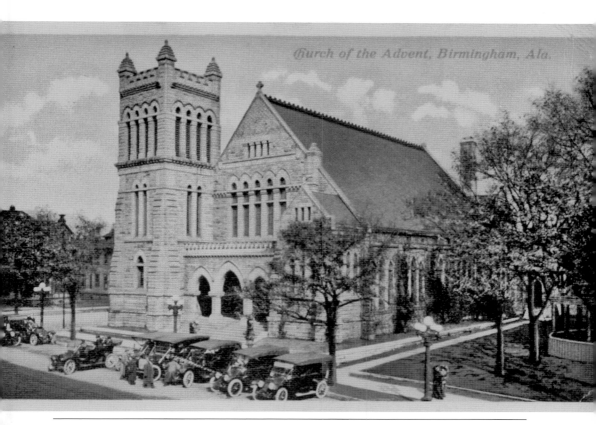

Church of the Advent, Birmingham, Ala.

The Church of the Advent was among the first churches built in Birmingham. The original frame structure, seating about 200, was constructed in 1873 behind the current building. Construction of the present building actually began in 1887 and was completed in 1893. Located at 2019 Sixth Avenue downtown, it became the cathedral of the diocese in 1982 and is now known as Cathedral Church of the Advent.

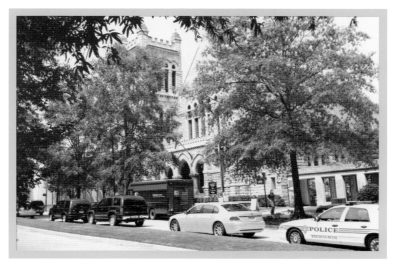

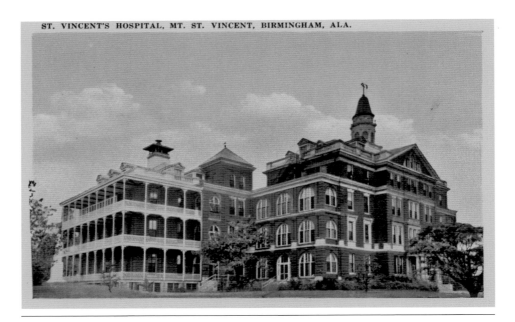

St. Vincent's, the first hospital in Birmingham, began at a temporary location in the mansion of Henry F. DeBardeleben in 1898. Construction started the next year, and St. Vincent's Hospital opened in 1900. Sister Chrysostom, the first administrator, became the first registered nurse in Alabama in 1916. The east wing, shown here on the left, opened in 1911. This current view of the original site shows only a small part of the huge medical complex located there today.

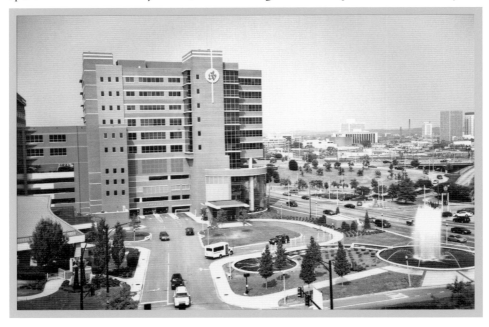

CHURCHES, HOSPITALS, AND MEDICAL FACILITIES

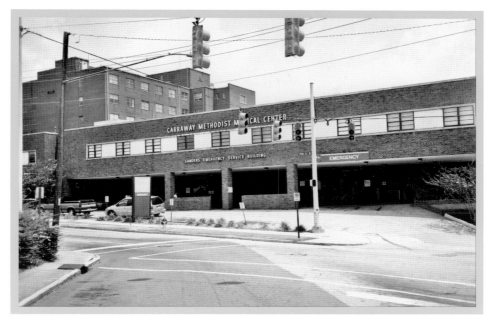

Dr. Charles N. Carraway first opened a 16-bed hospital and office next to his home in Pratt City. Inspired by his study with Charles and William Mayo of the Mayo Clinic, he purchased a lot on the corner of Sixteenth Avenue and Twenty-fifth Street in 1916 and opened the Norwood Hospital. In 1926, he opened a clinic next door, which became Alabama's first multi-specialty medical group practice. Today it operates separately as Norwood Clinic, and the hospital is now known as Carraway Methodist Medical Center.

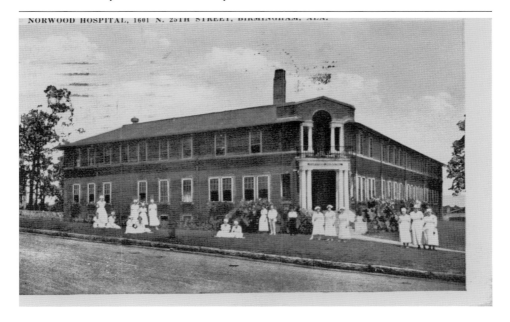

CHURCHES, HOSPITALS, AND MEDICAL FACILITIES

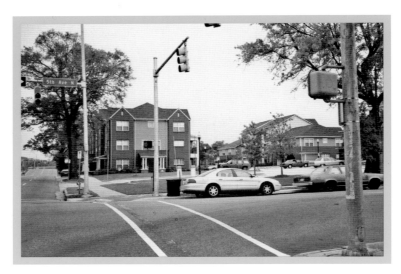

Birmingham General Hospital was built c. 1910 at 2400 Fifth Avenue, one block south of Powell School. The name had changed to Alabama General Hospital by 1930. It had become a rooming house in 1938, aptly named the Greystone since it was constructed of gray-colored stone. In the background of the current photograph is Park Place, a mixed-use, mixed-income community that is replacing a public housing project built in 1940.

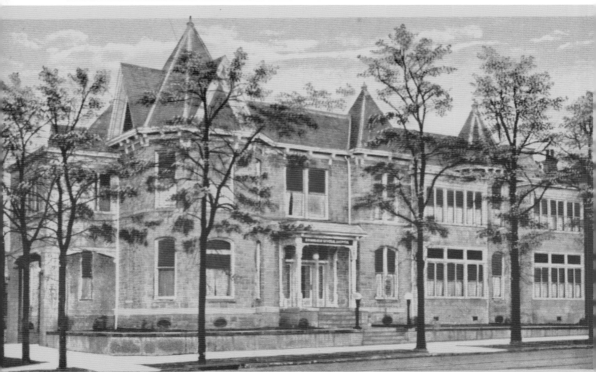

BIRMINGHAM GENERAL HOSPITAL, BIRMINGHAM, ALABAMA.

CHURCHES, HOSPITALS, AND MEDICAL FACILITIES

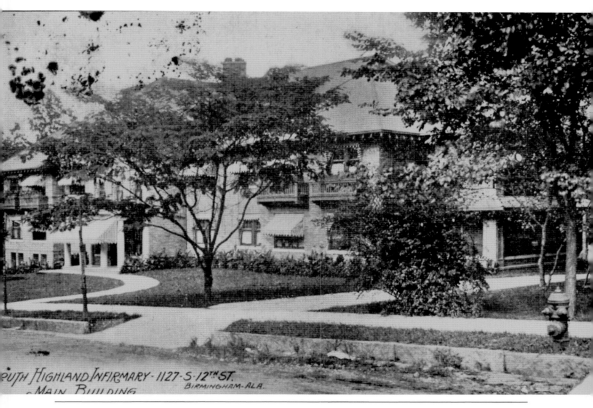

SOUTH HIGHLAND INFIRMARY - 1127-S-12TH ST.
MAIN BUILDING BIRMINGHAM-ALA.

South Highland Hospital opened in 1910 on Twelfth Street, just south of Eleventh Avenue. For many years, it was the primary health care provider for American Cast Iron Pipe Company (ACIPCO) employees. HealthSouth Corporation purchased the property in 1989 and built a new facility and headquarters on the site. UAB purchased the hospital, which adjoins their campus, in 2006 and named it UAB Highlands. The present view shows the emergency room entrance sitting at the original site.

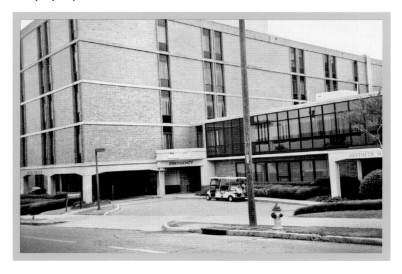

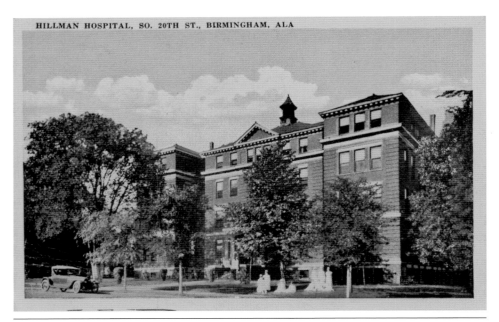

HILLMAN HOSPITAL, SO. 20TH ST., BIRMINGHAM, ALA

Hillman Hospital was established in 1897, and this building was constructed in 1902. It was named for Thomas T. Hillman, the president of Tennessee Coal and Iron Company (TCI), who gave $20,000 in TCI bonds for a trust. The newly established Medical College of Alabama acquired this facility in 1944, and today it is part of the UAB Medical Center Complex, which has almost covered it up. It is located on the Southside at Sixth Avenue and Twentieth Street.

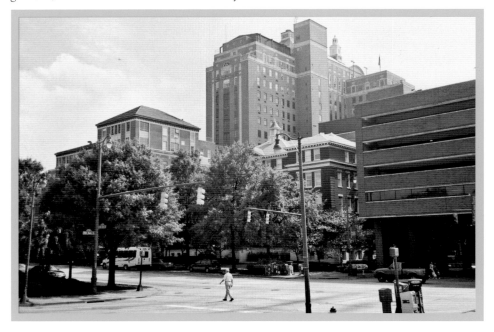

CHURCHES, HOSPITALS, AND MEDICAL FACILITIES

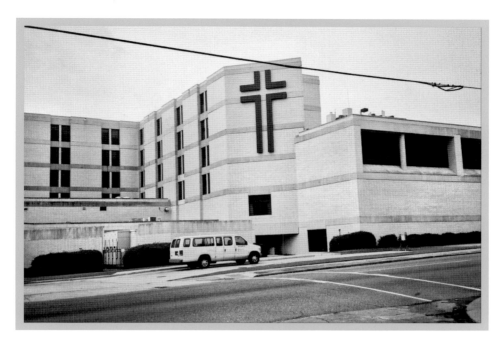

The Birmingham Infirmary, shown at the left in this old postcard view, began in 1906 on Tuscaloosa Avenue. The brick addition, seen to the right, was the first of many that would follow. Later, after joining the Baptist Health System, it was named West End Baptist Hospital. Today none of these old original buildings exist, and it is called Baptist Medial Center–Princeton. The current photograph shows the location of the original structure, but not seen is the huge hospital complex that is located there today.

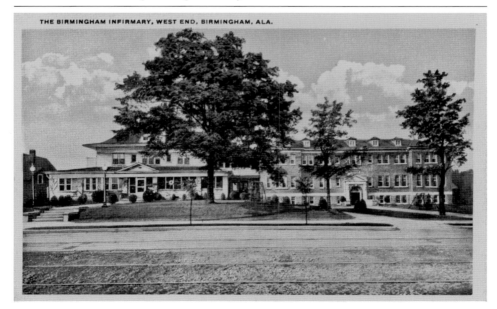

THE BIRMINGHAM INFIRMARY, WEST END, BIRMINGHAM, ALA.

The Medical Arts Building opened in 1931 on Twentieth Street, in the heart of Five Points South. Located near the South Highland Hospital, St. Vincent's Hospital, and Hillman Hospital, it provided office space for physicians, as well as dentists and other health-related professionals. This worked well for over 40 years until hospitals began to build their own professional buildings. After major renovation, the Medical Arts Building then became the Pickwick Hotel and Suites while still retaining its architectural integrity.

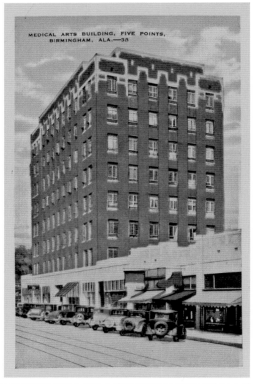

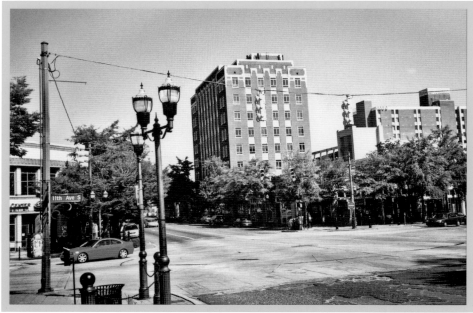

CHURCHES, HOSPITALS, AND MEDICAL FACILITIES

SCHOOLS

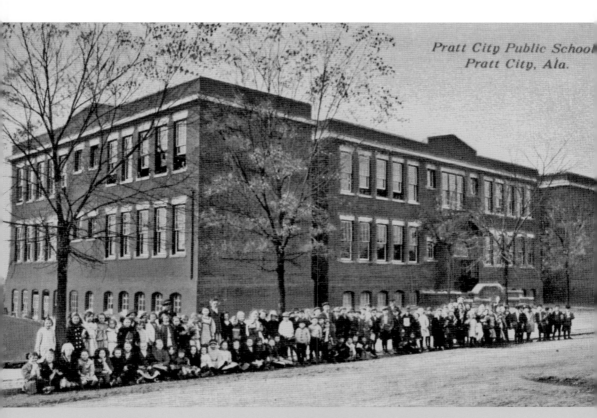

Pratt City Public School
Pratt City, Ala.

The Pratt City School was operated by the City of Pratt prior to becoming a part of Birmingham in 1910. This building was located on Third Street, between Carline Avenue and Avenue U, in Pratt City. The students appear to be posing for some special occasion. All that remains of this school is an empty lot.

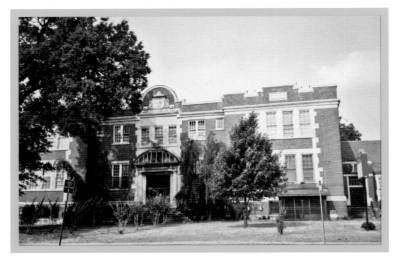

Elyton School was named for the city of Elyton, the precursor of Birmingham. What then was the center of Elyton later became the corner of Cotton Avenue and Broad Street. After becoming a part of Birmingham in 1910, the address had changed to 6 Tuscaloosa Avenue SW. The building currently sits empty and in poor condition. It appears the property may be sold to the family court facility, which is located nearby.

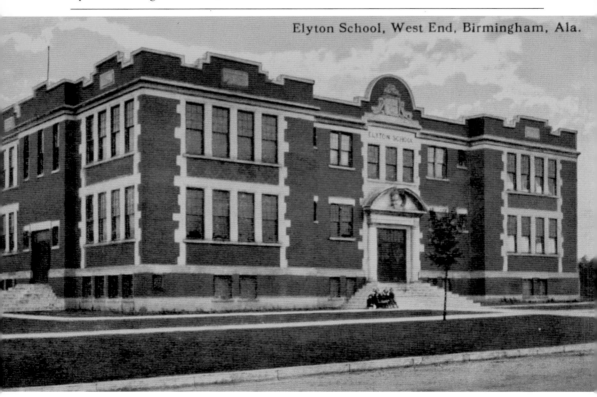

Elyton School, West End, Birmingham, Ala.

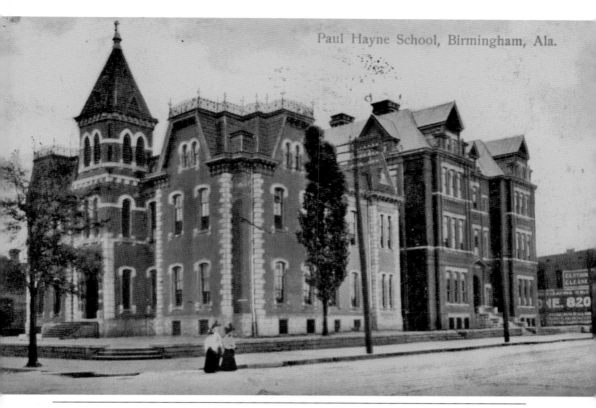

Paul Hayne School, Birmingham, Ala.

Paul Hayne School was built in 1886 on the southeast corner of Fifth Avenue and Twentieth Street. It functioned as an elementary, high, and vocational school. It was demolished in the 1950s, and the Birmingham Federal Savings and Loan building was erected on that site. Now located there is UAB's Kirklin Clinic, named for Dr. John W. Kirklin, a cardiac surgery pioneer who performed the world's first series of open-heart operations using a heart-lung machine. This building was designed by world-renowned architect I. M. Pei.

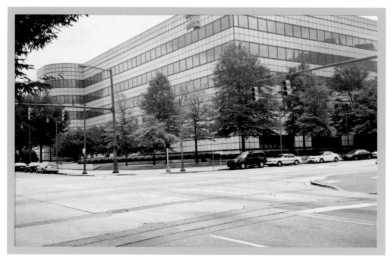

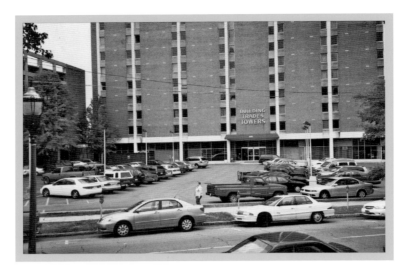

South Highland School was located at 2030 Magnolia Street on the Southside, adjacent to the Five Points South intersection. This *c.* 1901 view shows how it looked when the city of South Highland operated the school, prior to becoming a part of Birmingham. It closed in 1964, and in its place is the Building Trades Tower Retirement Home. The tunnel under Twenty-first Street, placed there for school students to safely cross under the street to the playground, still remains.

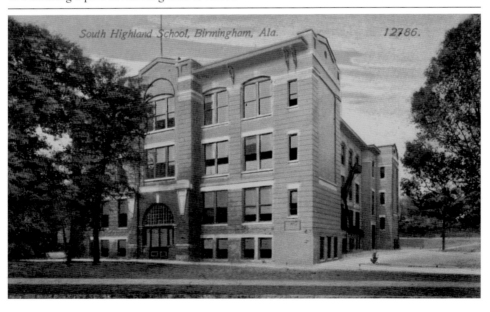

South Highland School, Birmingham, Ala. 12786.

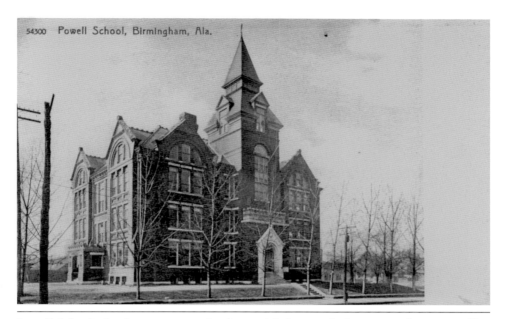

54300 Powell School, Birmingham, Ala.

Powell School, the first primary school in Birmingham, was established by John Herbert Phillips in 1883, when he became the first superintendent of the Birmingham School System. This *c.* 1905 view is the second and current building, constructed in 1886. Mary Cahalan was the first principal. A statue of her was crafted in 1908 by Guiseppe Moretti, the sculptor of Vulcan, and was erected in East Park across from Powell School. It was later moved to Linn Park (see page 77).

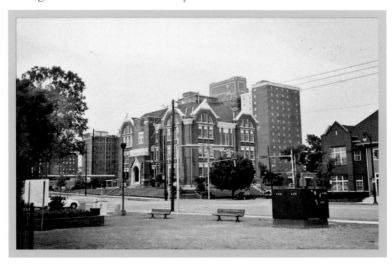

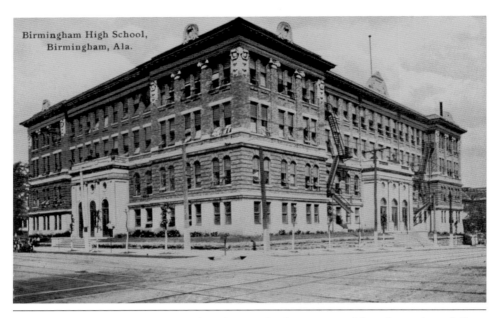

Birmingham High School,
Birmingham, Ala.

This is the old Birmingham High School, built in 1906 on the northwest corner of Seventh Avenue and Twenty-fourth Street. The name changed to Central High when a second high school was constructed in the city in 1911. Sadly this building was completely destroyed by fire in 1918. The school was renamed for John Herbert Phillips, the longtime superintendent, after his death in 1921. The current building was constructed in 1923 and continued as Phillips High School until 2000. It is now undergoing renovation for use as an elementary school.

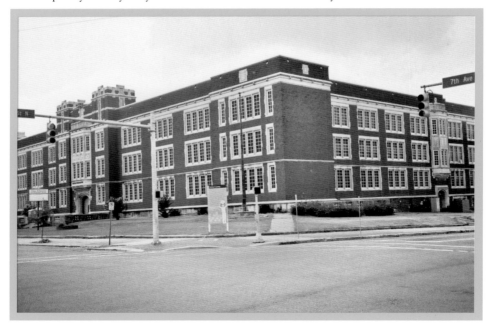

The Birmingham Seminary, founded by Loulie Compton in 1897, was on Fifth Avenue between Seventeenth and Eighteenth Streets. The buildings seen here are the school on the left, the home for boarding students in the middle, and the children's cottage, just out of view on the right. When Loulie Compton died in 1912, the school's name was changed to the Loulie Compton Seminary. The school later moved near Highland Avenue on Sycamore Hill. Currently located at the original location is a seven-level parking facility with ground-floor businesses.

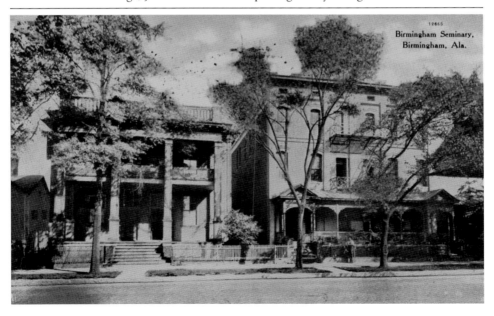

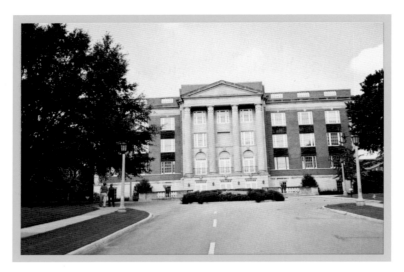

Owenton College opened in 1898 on a hill west of Birmingham, in an area later to become College Hills. The name was changed to Birmingham College in 1906, and this building was called Owen Hall. It merged with Southern College in 1918 and became Birmingham-Southern College, which it remains today. This building was used as barracks for soldiers during World War I. It was demolished in 1927, and the current building, Munger Memorial Hall, opened in 1928.

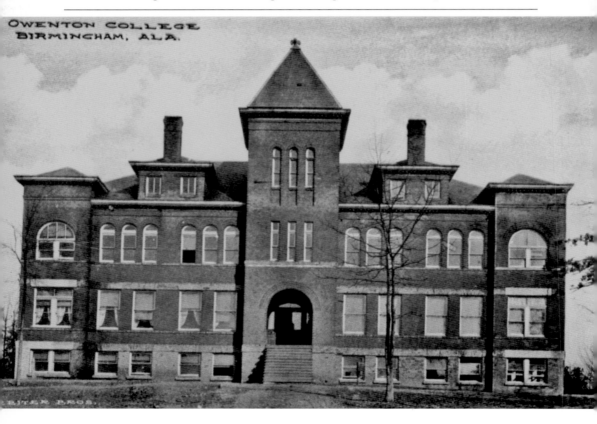

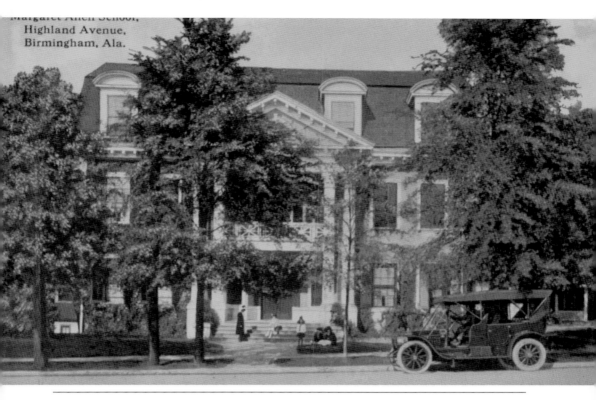

Margaret Allen School,
Highland Avenue,
Birmingham, Ala.

The Margaret Allen School for young ladies, as seen in this *c.* 1917 view, was located at 2144 Highland Avenue on the Southside. The school was operated there from 1906 until 1934 by Willie M. Allen, the principal, and her two sisters, Beff and Ruth. In addition to the regular academic subjects, they also taught French, dancing, and art. The building disappeared long ago, and in its place are the offices of Lanny Vines and Associates, a prominent Birmingham law firm.

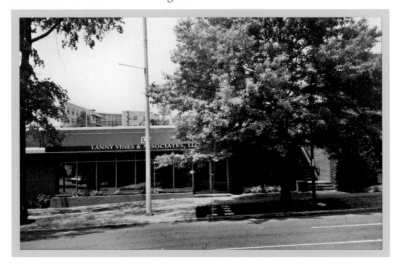

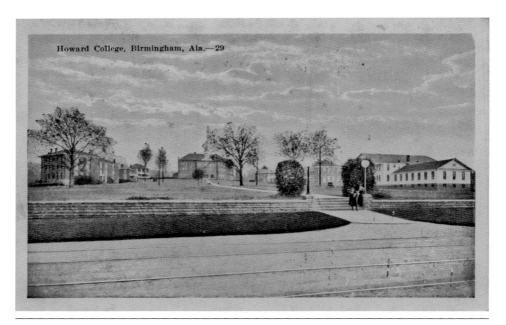

Howard College, Birmingham, Ala.—29

Howard College, founded in 1842 in Marion, Alabama, moved to this site in 1887. Construction began on a new campus and was completed in 1892. After over 70 years at that location, it moved to Shades Valley in 1957. One of its famous football players, and a coach, was Bobby Bowden, current head football coach at Florida State University. In 1965, Howard College became Samford University. A modest apartment complex now occupies this old campus site in the East Lake community.

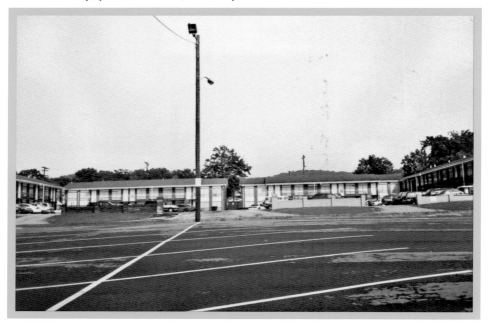

SCHOOLS

PLACES OF RESIDENCE

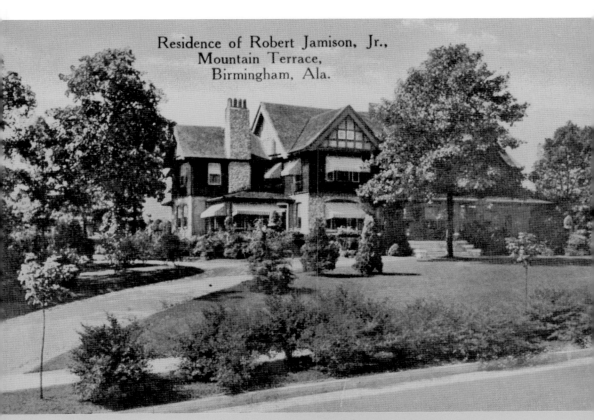

Residence of Robert Jamison, Jr.,
Mountain Terrace,
Birmingham, Ala.

This is the Crescent Road home of Robert Jemison Jr., who developed this Mountain Terrace neighborhood in 1906. It was the first sizeable residential development to have asphalt streets and concrete sidewalks, curbs, and gutters. He also developed Mountain Brook, Bush Hills, Central Park, and Ensley Highlands. After a century, his old home is still as stately as ever.

Quinlin Castle was built in 1926 on Ninth Avenue, between Twentieth and Twenty-first Streets on the Southside. For many years, it was known as the Royal Arms Apartments. Several years ago, Southern Research Institute, adjacent to the property, wanted to purchase the then-vacant building and tear it down to make room for a parking lot. It was temporarily rescued by the city and saved from demolition for the time being. However, its future is still uncertain.

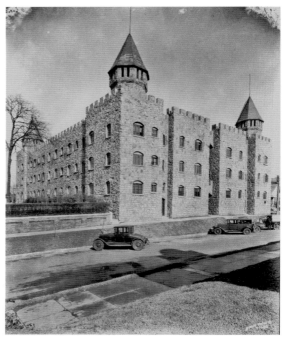

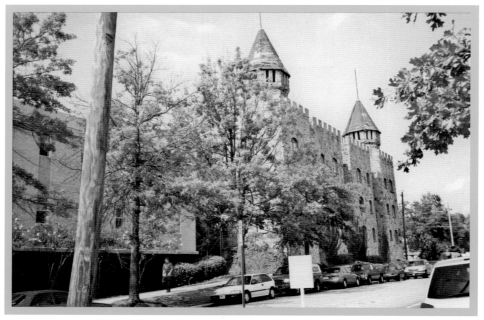

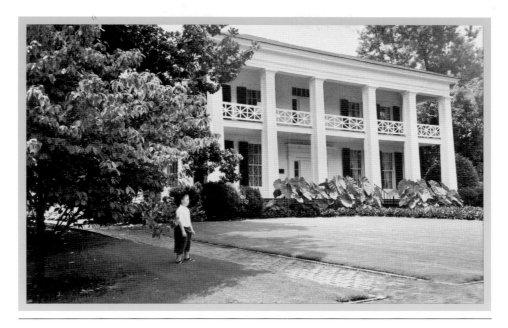

William S. Mudd built this antebellum home in 1846 and raised 10 children there. During the Civil War, it was used by Gen. James H. Wilson as his headquarters while his troops were destroying the iron-making furnaces and foundries in the area. Birmingham was not yet a city, but the town of Elyton was nearby. The home was purchased in 1886 by Henry DeBardeleben and then in 1902 by Robert S. Munger, who named it Arlington. Acquired by the City of Birmingham in 1953, it is now a museum.

This was the Morris Adler home as it looked in 1890. Located at 2147, it was one of the first houses built on Highland Avenue. Morris Adler was president of Corona Coal Company and owned the Morris Company with Edgar Adler. To the right of his house, and out of view, was the equally impressive home of M. P. Messer, owner of Messer Realty Company. On that site now is One Highland Plaza, an office building housing doctors, surgeons, attorneys, and various agencies.

PLACES OF RESIDENCE

The first residential areas in Birmingham were downtown, as this view of Fifth Avenue illustrates. Notice that the modes of transportation included walking, horse and carriage, and very early automobiles, although the streets are still unpaved. On these corners in the foreground, the Molton Hotel (see page 22) would open in 1913 and the Tutwiler Hotel (see page 23) would open in 1914. Both hotels have now been replaced with the headquarters of Compass Bank on the left and Regions Financial Corporation on the right.

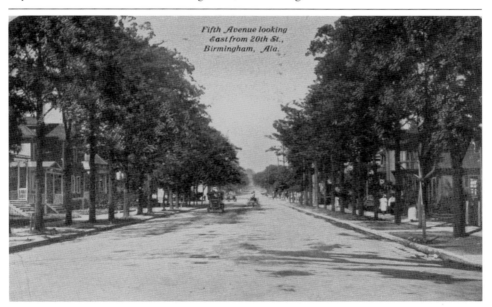

Fifth Avenue looking
East from 20th St.,
Birmingham, Ala.

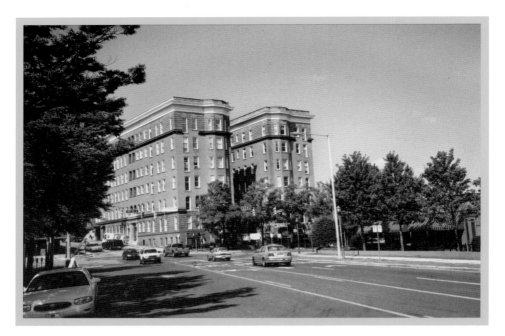

The Terrace Court Apartment building was constructed in 1908 by Richard W. Massey, the owner of Massey Business College. This was the first high-rise apartment building in Birmingham, possibly in the South. There were eight apartments on each floor, four on each wing. Amenities included a roof garden, dining room, and lounge. It has been an apartment complex for almost a century, but now $5 million is being invested to convert it into 26 condominiums.

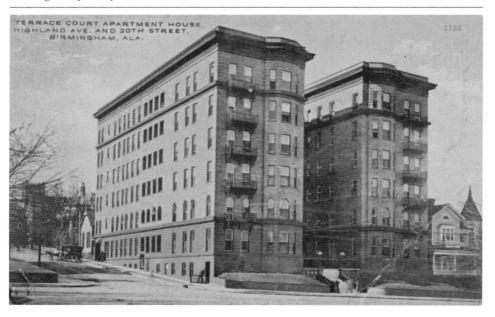

TERRACE COURT APARTMENT HOUSE,
HIGHLAND AVE. AND 20TH STREET,
BIRMINGHAM, ALA.

1153

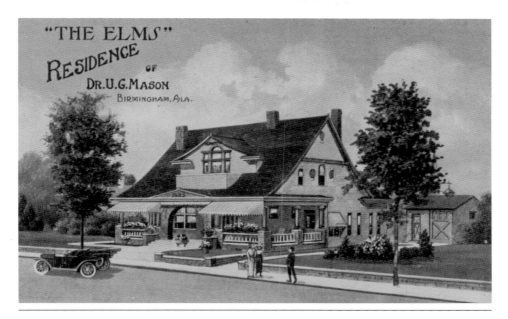

"THE ELMS" RESIDENCE OF DR. U.G. MASON BIRMINGHAM, ALA.

Dr. Ulysses Grant Mason graduated from Meharry Medical College and was licensed to practice medicine in Alabama in 1895, most likely making him the first black doctor in Birmingham. He built this residence and office in 1910 at 1525 Seventh Avenue downtown. In 1911, he founded the Prudential Savings Bank, which he later sold to the Penny Savings Bank. By 1930, the house had become the Bradford Funeral Home. All that remains of his residence are portions of the stone wall by the sidewalk.

Walker Percy's family lived in this house when he was born at St. Vincent's Hospital (see page 38) in 1916. It was located at 2217 Arlington Avenue, on the Southside. He was a renowned author, producing such works as *The Moviegoer*, *The Last Gentleman*, *Love in the Ruins*, and many others. When the Red Mountain Expressway (now the Elton B. Stephens Expressway) was constructed, his old residence was one of the casualties.

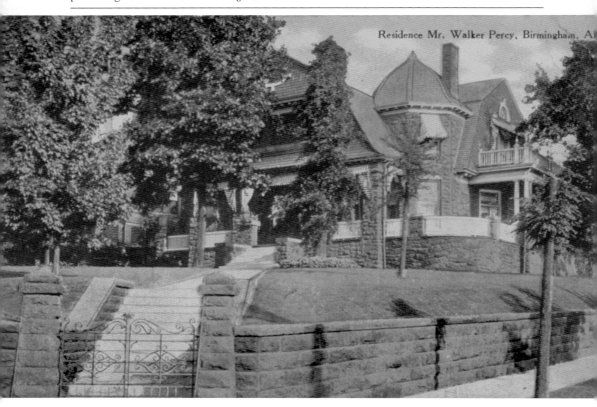

Residence Mr. Walker Percy, Birmingham, Al

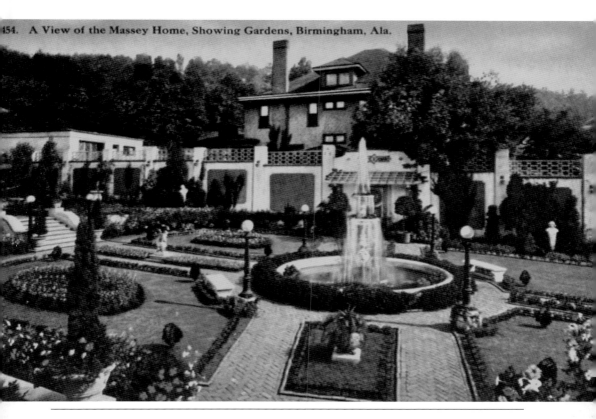

454. A View of the Massey Home, Showing Gardens, Birmingham, Ala.

Richard W. Massey's residence, built in 1905, was located high atop Red Mountain. He founded the Massey Business College in Birmingham in 1904 and soon had seven others around the South. He started with one rented room and a few rented typewriters. By the 1920s, he had become vice president of the Protective Life Insurance Company and Roberts and Sons. His beautiful home became another casualty of the cut through Red Mountain for the Red Mountain Expressway.

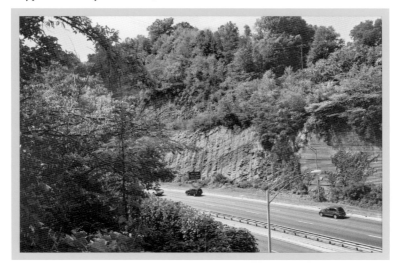

This is an early-1900s view of First Avenue as it comes past Fifty-ninth Street in the town of Woodlawn. This wide street, with dual streetcar tracks, passed through Woodlawn on the way to East Lake Park, an early recreational and housing development. Parks were used by early developers, like the Elyton Land Company, to create real-estate markets on their property. Woodlawn, once a separate town, is now a community in Birmingham. The business area can be seen in the background in the current view.

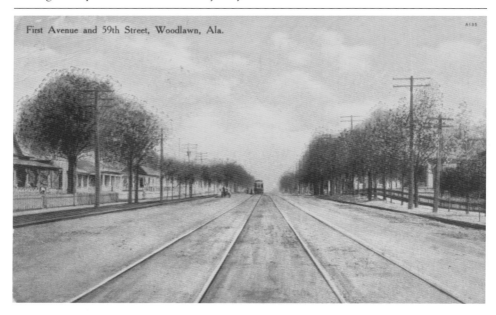

First Avenue and 59th Street, Woodlawn, Ala.

PLACES OF RESIDENCE

CHAPTER 6

PARKS, RECREATION, AND ENTERTAINMENT

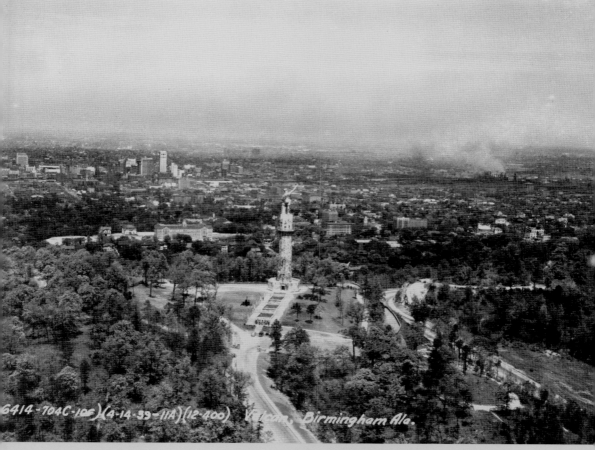

6414-704C-10F)(4-14-39-11A)(12-400) Vulcan, Birmingham Ala.

This view shows Vulcan Park overlooking Birmingham from atop Red Mountain, shortly after the 1939 grand opening ceremonies. *Vulcan*, a 56-foot cast-iron statue designed by Guiseppe Moretti, was the city's exhibit for the 1904 St. Louis World's Fair. After returning to Birmingham and spending over 30 years at the state fairgrounds, *Vulcan* was erected on Red Mountain, where he still stands today.

The first Alabama State Fair was held in 1892, and this view shows one in progress shortly after *Vulcan* was placed at the fairgrounds in 1906. Note that Vulcan's right arm has been attached incorrectly. Just to the right of *Vulcan* is the paddock, and horses are being prepared for a race on the track, seen at top right. The state fair was discontinued in 2001 and no longer exists. However, the track is still utilized for stockcar races and high school football games.

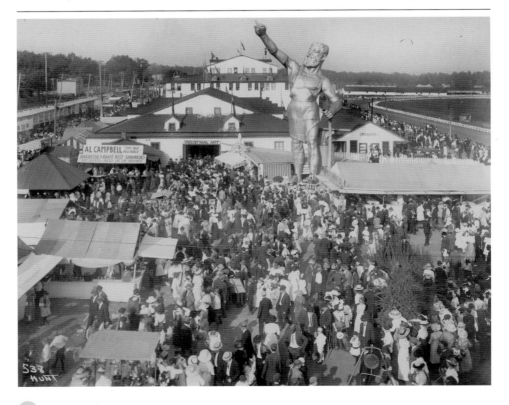

PARKS, RECREATION, AND ENTERTAINMENT

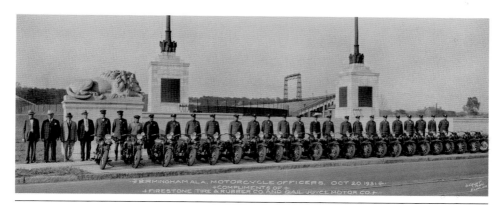

In 1931, these Birmingham motorcycle officers were showing off their Indian motorcycles in front of Legion Field. The promotional photograph was sponsored by Firestone tires and Gail Joyce Motor Company, the local Indian motorcycle dealer. The current view shows a tired old Legion Field, site of the football game where Bear Bryant, the legendary University of Alabama football coach, passed Amos Alonzo Stagg's record for most wins by a college football coach on November 28, 1981. It is now the home stadium for the UAB Blazers.

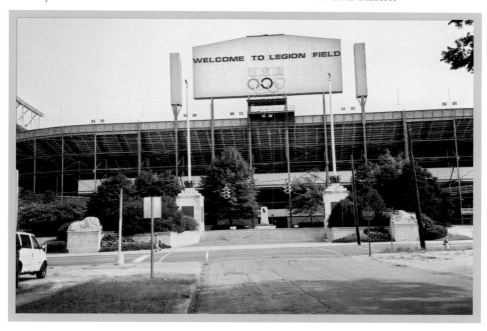

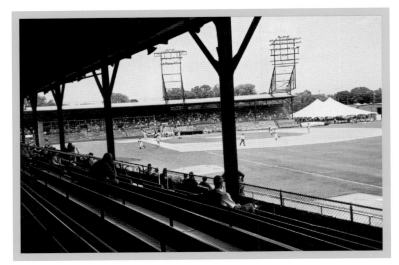

Rickwood Field, the oldest baseball park in America still operating, is shown in this photograph on opening day of the new ballpark. It was August 18, 1910, and there were over 10,000 fans in attendance to see the Birmingham Coal Barons play. Most stores downtown had closed, and all available streetcars were called into service. The Barons are still around, but they now play in a new ballpark. However, the annual Rickwood Classic game, seen in the current picture, takes place at old Rickwood with both teams dressed in period uniforms.

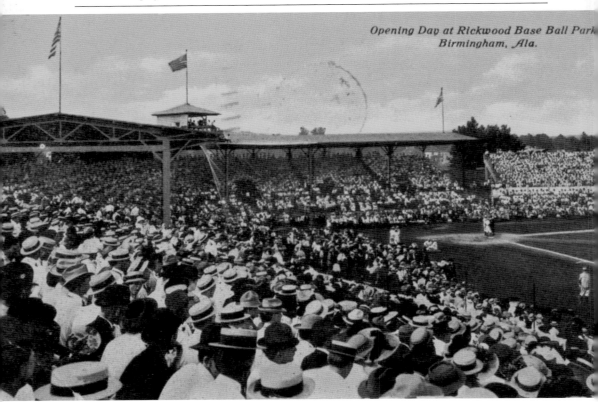

Opening Day at Rickwood Base Ball Park
Birmingham, Ala.

PARKS, RECREATION, AND ENTERTAINMENT

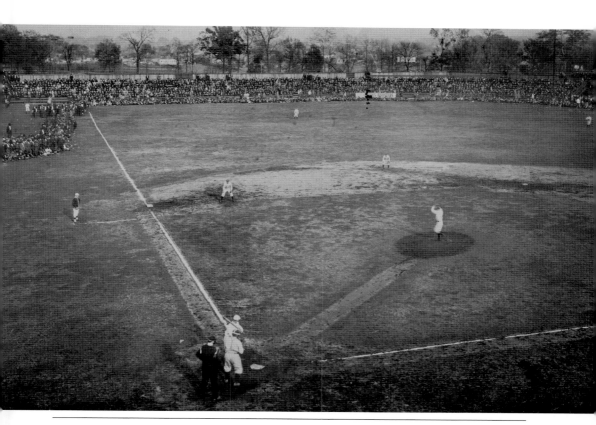

In this *c.* 1914 Birmingham Barons baseball game, the field looks pretty large, much larger than in the current picture. And for good reason, since the current outfield fence, with its re-created period signs, is much closer than the original rock wall behind it that measured 470 feet. That was the wall that Babe Ruth, Ty Cobb, Dizzy Dean, Willie Mays, and all those old Birmingham Black Barons had to swing for. Several movies, including *Cobb*, were filmed here, along with some baseball documentaries.

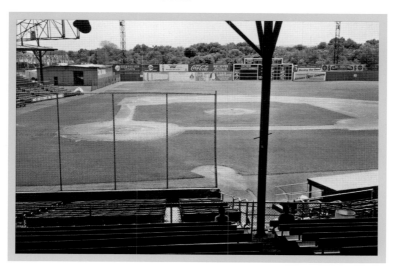

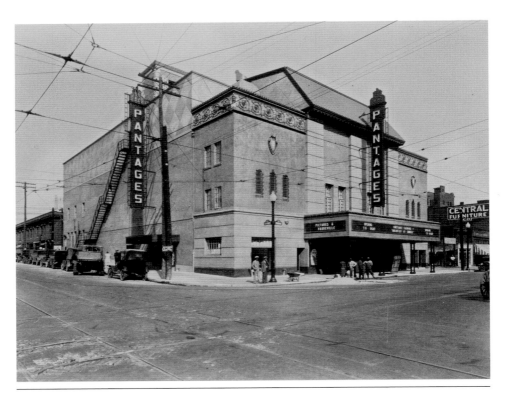

Breakfast at Sunrise, starring Constance Talmadge, was playing at the Pantages Theatre when this photograph was taken in 1927. Originally built in 1890 as a civic auditorium, it was the Bijou prior to becoming the Pantages. In its later days, it would be known as the Birmingham Theatre until it disappeared from the scene around 1946. The Citizens Trust Bank, now on this site, was founded by the late A. G. Gaston. In the right background is the Booker T. Washington Insurance Company, also founded by Dr. Gaston.

PARKS, RECREATION, AND ENTERTAINMENT

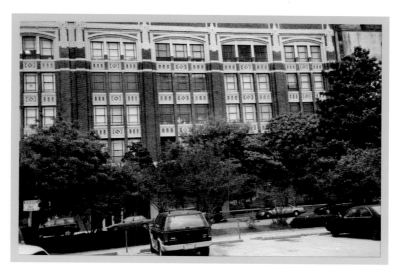

The Jefferson Theatre, located at 1710 Second Avenue, opened for the first time on March 7, 1900. Named for a famous stage actor of the time, it had three levels and seating for 1,600. What a sight it must have been when *Ben Hur* was presented in 1905, with the chariot race performed onstage with live horses. It was demolished in 1944, and the Phoenix Building, which served as the old Southern Bell headquarters for many years, now sits on that site.

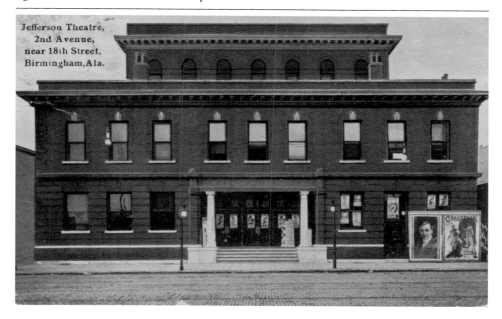

Jefferson Theatre, 2nd Avenue, near 18th Street, Birmingham, Ala.

The Southern Club, an exclusive social club where a membership was highly prized, was on the northwest corner of Fifth Avenue and Twentieth Street. The building up the street to the right is the Birmingham Athletic Club.

The YMCA would be built on the next lot in 1911. The AmSouth Center now sits on that corner, and those three historic buildings have disappeared.

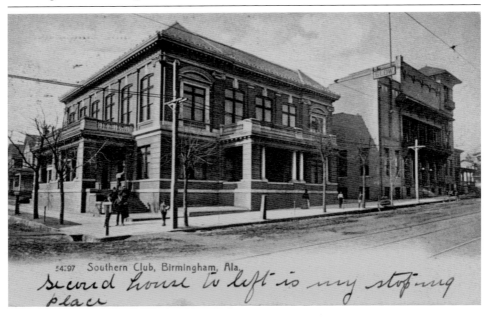

54:97 Southern Club, Birmingham, Ala.

Second House to left is my stopping place

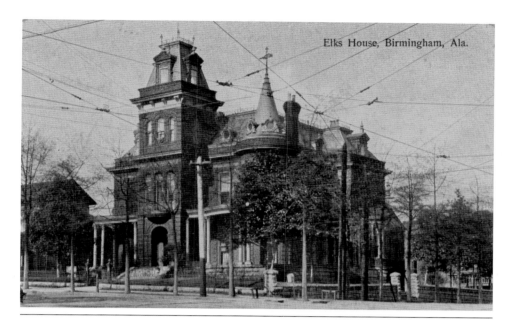

Elks House, Birmingham, Ala.

Alexander O. Lane, mayor of Birmingham from 1883 to 1885, resided here in 1888. His home was located on the northwest corner of Eighth Avenue and Nineteenth Street. Lodge No. 79 of the Fraternal Order of Elks moved into his old residence *c.* 1900 and remained there for over 80 years. The Alabama School of Fine Arts, founded in 1968, built a new facility here in 1993. They have grades 5–12, no tuition, and along with core academic programs include creative writing, dance, music, theater arts, and visual arts.

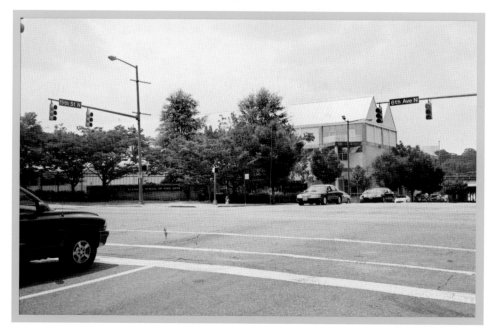

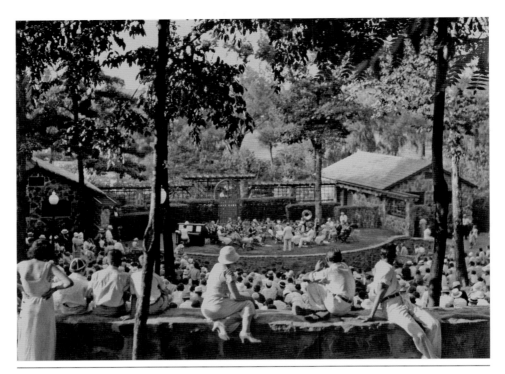

Avondale Park has been here since long before Birmingham became a town. During the Civil War, Union soldiers from Wilson's Raiders attempted to water their horses here and were driven away by the Confederate pickets of Truss's Home Guards. After Birmingham was founded, much of the early water came from the springs here and was sold by the barrel. This picture shows a concert in progress *c.* 1920 in the amphitheater constructed of native sandstone. The amphitheater, seen in this current view, still looks pretty much the same.

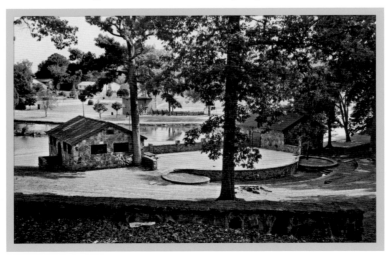

PARKS, RECREATION, AND ENTERTAINMENT

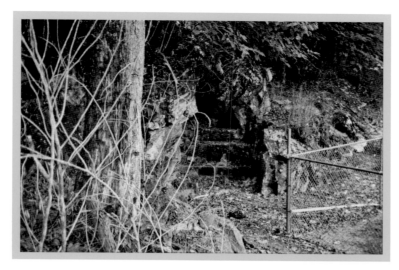

This spring-fed grotto, with water bubbling to the surface in Avondale Park, had been a source of fresh, clean water for scattered farms in the area since the early 1800s. The springs once flowed down the middle of Spring Street, now Forty-first Street. This opening has been closed for many years and goes unnoticed by residents from the neighborhood. Perhaps it gets a glance at times when a baseball is retrieved that has cleared the right-field fence of the youth baseball field located there now.

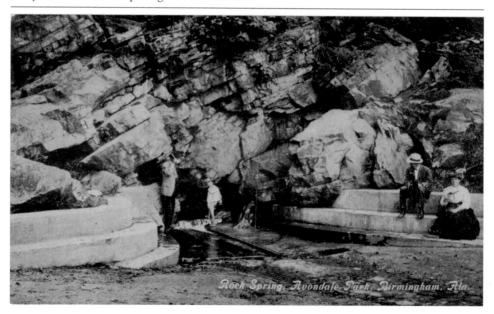

Rock Spring, Avondale Park, Birmingham, Ala.

West Park was set aside by the Elyton Land Company in 1871 for a public park. It was renamed Kelly Ingram Park after Birmingham native Osmond Kelly Ingram, the first American sailor killed in World War I. It was the site of civil rights demonstrations in the 1960s and remains a focal point of the civil rights struggle. The Birmingham Civil Rights Institute is in the left background of this current view, and the historic Sixteenth Street Baptist Church is to the right.

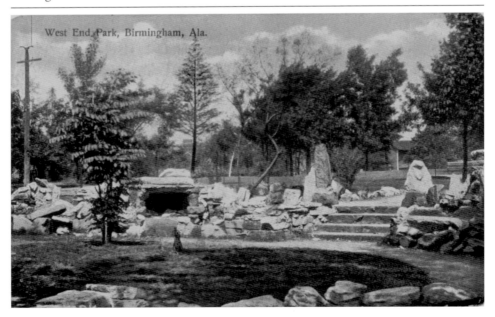

West End Park, Birmingham, Ala.

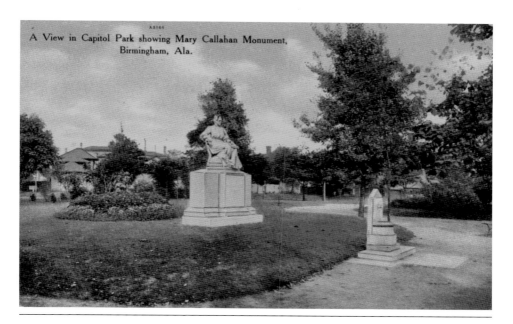

A View in Capitol Park showing Mary Callahan Monument, Birmingham, Ala.

Mary A. Cahalan was a teacher and the first principal of Powell School, the first public school in Birmingham (see page 49). Guiseppe Moretti, the creator of *Vulcan*, sculpted this statue of her, which was initially placed in East Park, across from Powell School in 1908. It was later moved to Capitol Park (now Linn Park) where it remains today. When placed there, the park was surrounded by fine large homes. It is now surrounded by the city hall, county courthouse, and the Birmingham Museum of Art.

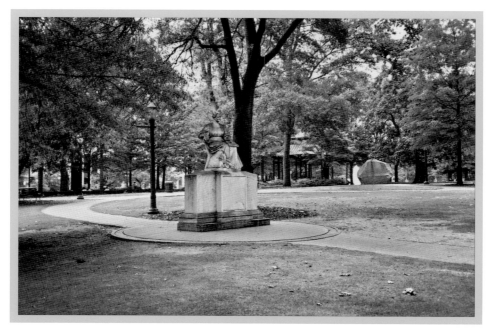

North Birmingham was the only community with two neighborhood movie theaters. One was this North Birmingham Theatre on Thirtieth Avenue and the other was the Delmar Theatre, which was around the corner on Twenty-seventh Street. It took all day Saturday for the neighborhood children to see the two feature movies, Movietone newsreel, cartoon, Three Stooges comedy, continuing serial, and previews of coming attractions at each of the two theaters for 10¢ each. All that remains is this small, seldom-used parking lot.

PARKS, RECREATION, AND ENTERTAINMENT

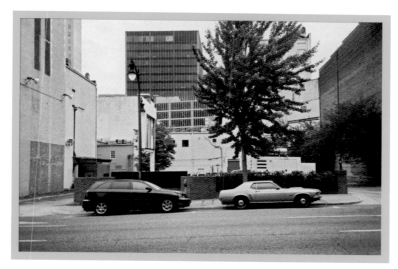

The Empire Theatre was located on Third Avenue, next to the Watts Building. Originally built for silent movies, it adjusted and continued to operate until 1984. In this photograph, a large group of *Birmingham News* paperboys are being treated to a Sherlock Holmes movie, most likely winners in some sort of newspaper contest. Notice the Empire is advertising 500 low-priced balcony seats. The building was demolished years ago and all that remains is this small surface parking lot.

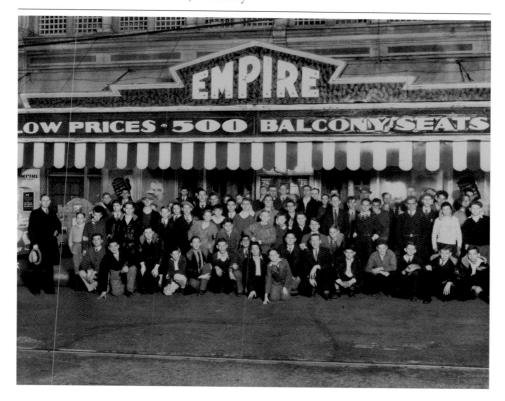

The 1906 University of Alabama football team is posing in the middle of Twentieth Street, in front of the Birmingham Athletic Club. Alabama only played two games that season, Auburn and Tennessee, both at the Fairgrounds in Birmingham. They had previously played the Birmingham Athletic Club twice in 1892, twice in 1893, and then again in 1896. The Birmingham Athletic Club never appeared on the Alabama schedule after that. Located at that site today is an AmSouth Bank branch.

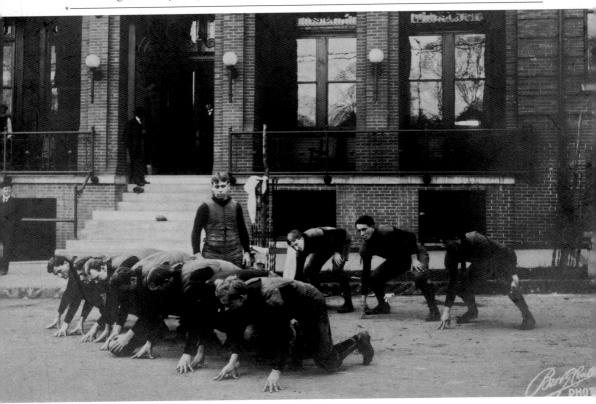

PARKS, RECREATION, AND ENTERTAINMENT

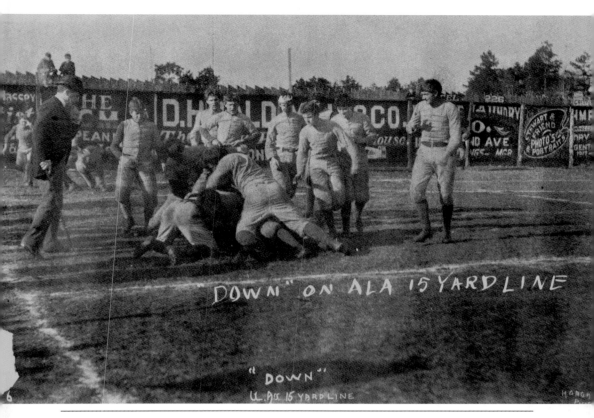

"DOWN" ON ALA 15 YARD LINE

"DOWN"
U. A. 15 YARD LINE

On Wednesday, February 22, 1893, the first Alabama-Auburn football game took place at Lakeview baseball field, next to Lakeview Park. It was actually the 1892 season but this game was added after the 1892 season had ended in November. A special train had transported fans from Montgomery. The *Birmingham Age Herald* reported that 5,000 people were there to watch and a trophy was presented to the winner. This site was a men's softball complex for many years until it became a large parking lot for a Compass Bank administrative facility.

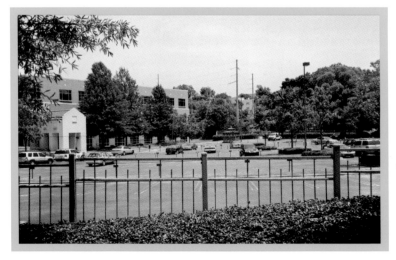

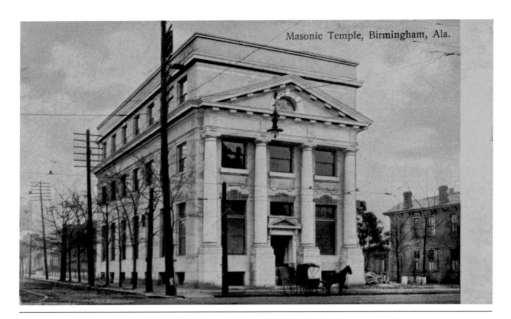

Masonic Temple, Birmingham, Ala.

This Masonic Temple was constructed on the southeast corner of Sixth Avenue and Nineteenth Street in the early 1900s. It was replaced in 1922 with a much larger building to house Masonic administrative offices. In 1925, the auditorium was converted into a vaudeville theater known as the Temple Theatre. It produced stage shows and later became one of the favorite downtown movie houses. It still showed first-run movies until it was demolished in 1970. The AmSouth Bank headquarters is located on that site now.

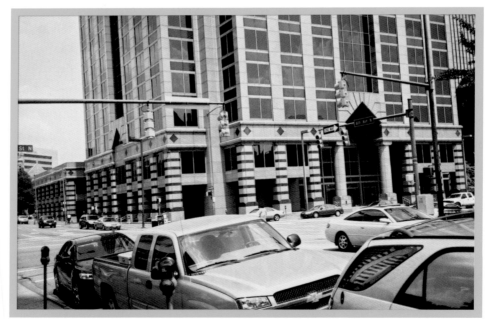

These ladies were sitting outside the YWCA building on what was then West Twentieth Street. It was April 29, 1916, and they were urging young ladies to join for only $1 a year. They were sitting in a Ford but the significance of the teddy bear holding the Ford sign is unclear. The YWCA would sell this building to the city in 1947 and move into the old Dixie-Carlton Hotel, where they remain today. A new city hall was built on that site in 1950.

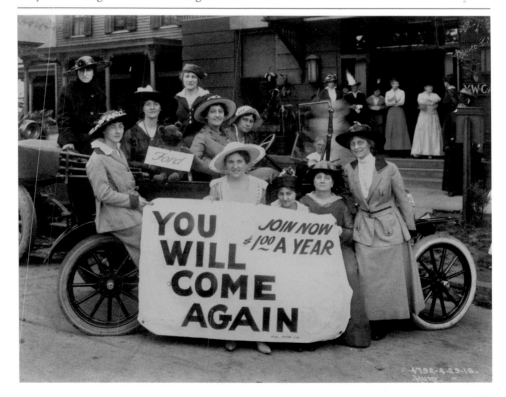

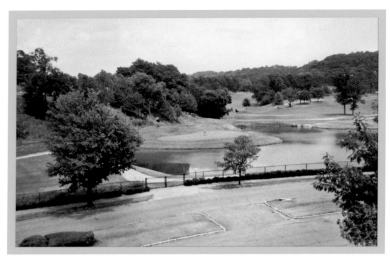

Lakeview Park was developed in 1884 by the Elyton Land Company. The property consisted of a large lake, casino, boat houses, gentlemen's club house, and a hotel that burned in 1893. The Birmingham Country Club moved here in 1904, after losing their golf course to industrial development in North Birmingham (see page 88). In 1928, the country club moved to Shades Mountain, and today this property is the site of the Highland Golf Club, formerly the Charlie Boswell Municipal Golf Course.

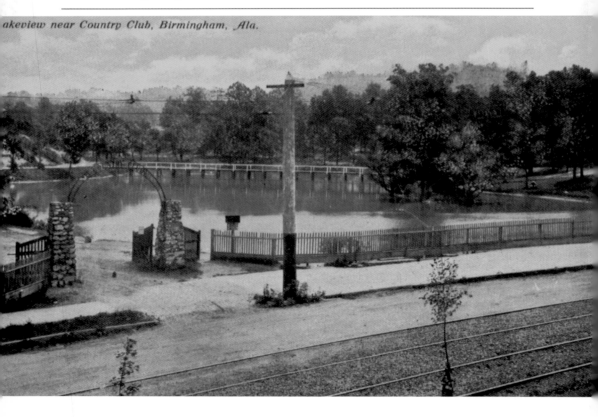

akeview near Country Club, Birmingham, Ala.

Parks, Recreation, and Entertainment

CHAPTER 7

INDUSTRIES, GOVERNMENT FACILITIES, AND OTHERS

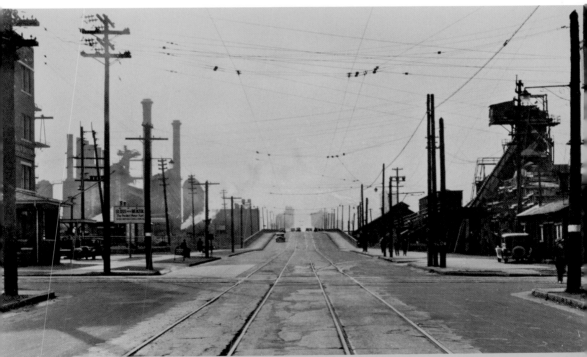

Sloss Furnace went into blast (fired up for the first time) in April 1882 on a 50-acre site donated by the Elyton Land Company. Purchased by U.S. Pipe and Foundry in 1952, Sloss continued to produce large quantities of iron until operations ceased in 1971. Referred to as the "City Furnace," it was literally in the shadows of the downtown skyline. Restored in 1983, it is now a museum.

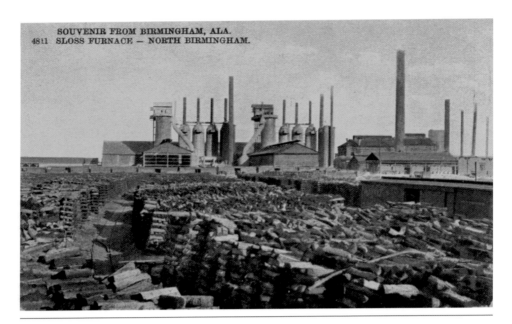

SOUVENIR FROM BIRMINGHAM, ALA.
4811 SLOSS FURNACE — NORTH BIRMINGHAM.

Sloss built a second furnace in the town of North Birmingham and began operation in 1889. Between the two furnaces, they were producing 175,000 tons of pig iron annually for local foundries. They began exporting overseas in 1894. All the furnaces are now silent, and those in North Birmingham were demolished years ago. Most residents who live nearby or work at the North Birmingham Division of the Birmingham Streets and Sanitation Department, now on that site, are not aware of the history that surrounds them.

The Mary Lee Mine opened in the 1880s at the north end of the young city of Birmingham. The coal mine got its name from Mary Lee, the daughter of Bartholomew Boyles, the owner. The dirt road seen behind the entrance to the mine was Stouts Road, constructed in the 1820s from Morgan County in north Alabama to the town of Elyton. The Mary Lee Mine site was destroyed during the construction of Interstate 65 and now lies beneath Fultondale Exit 266.

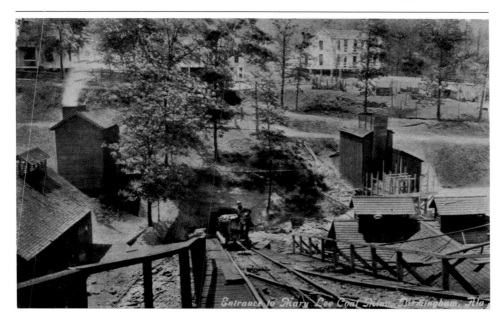

INDUSTRIES, GOVERNMENT FACILITIES, AND OTHERS

The Dimmick Pipe Works was built in 1904 on the North Birmingham site of what had been the nine-hole golf course of the Birmingham Country Club. Dimmick Pipe became Kilby Pipe Company in 1927, which became a division of Weir-Kilby Corporation in the 1980s. Over 100 years later, there is still pipe stored here, only now it belongs to the North Birmingham Plant of U.S. Pipe and Foundry, a wholly owned subsidiary of Walter Industries, Inc.

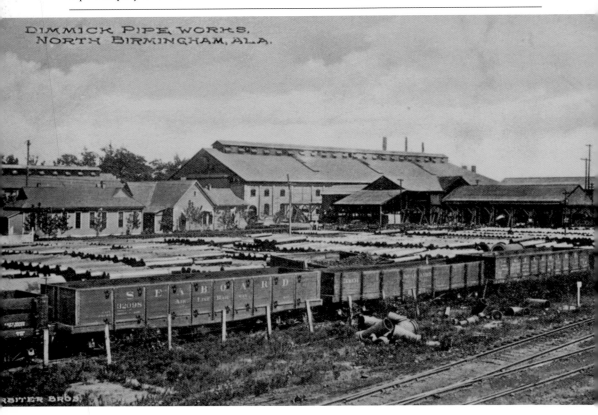

INDUSTRIES, GOVERNMENT FACILITIES, AND OTHERS

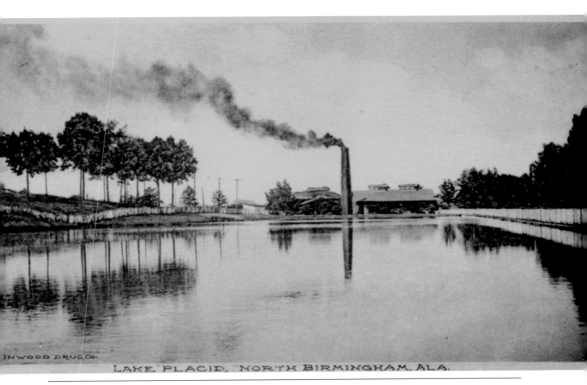

LAKE PLACID, NORTH BIRMINGHAM, ALA.

The Elyton Land Company built this one-million-gallon reservoir in North Birmingham in 1873. Water was pumped out of Village Creek and piped into the city a few miles away. Rapid population growth necessitated another source of water, and a canal was dug in 1887 from Five Mile Creek, northeast of Birmingham and near the city of Tarrant, and pumped into the reservoir. A few years later, water from the Cahaba River became the primary source. This dry lake bed is all that remains today.

This dramatic picture captures the Birmingham City Hall during a fire in 1925. The top floor and tower were heavily damaged and removed. Built in 1901, it was located on the southwest corner of Fourth Avenue and Nineteenth Street. Although suffering another fire in 1944, it continued to handle city business there until a new city hall was built across from Linn Park in 1950. At this location now is a three-level public parking deck.

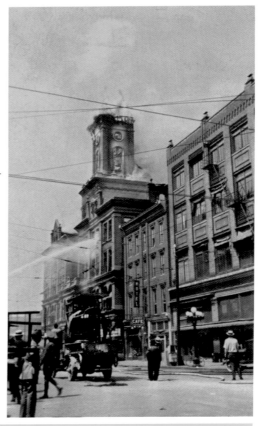

INDUSTRIES, GOVERNMENT FACILITIES, AND OTHERS

The first U.S. Weather Bureau building was constructed in the Fountain Heights community in 1907. It had formerly been housed in the Title Guarantee Building downtown. The Department of Agriculture also maintained offices there for some years, as well as possibly other agencies. Edgar C. Horton was the official in charge from about 1917 until this station merged with the weather station at the airport in 1945. Nice, large, two-story houses appeared all around there in the 1920s, but most are either gone or in poor condition.

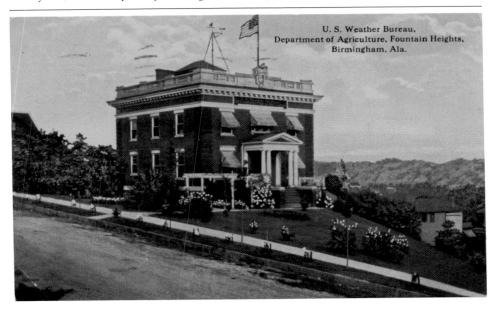

U. S. Weather Bureau, Department of Agriculture, Fountain Heights, Birmingham, Ala.

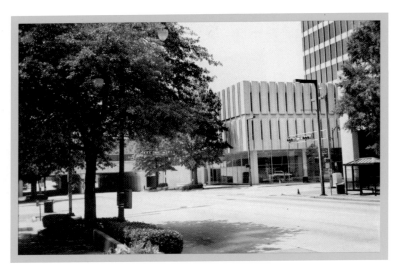

It is Sunday, May 1, 1898, and over 700 Birmingham young men are boarding the train at the Louisville and Nashville (L&N) Station on Morris Avenue, headed for duty in the Spanish-American War. A large crowd has gathered to see them off. The old station, built in 1886, was demolished, and in 1962, the Bank For Savings Building was constructed on that site. Located there now is the Two North Twentieth Building. Note in the current picture that the railroad tracks have been elevated.

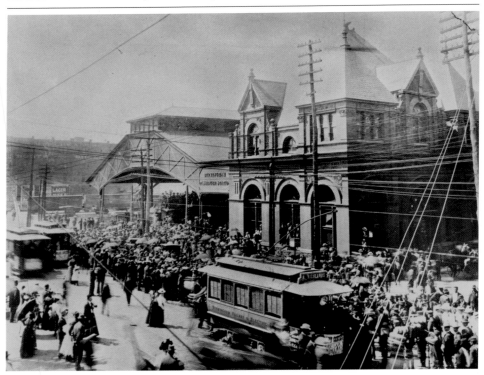

INDUSTRIES, GOVERNMENT FACILITIES, AND OTHERS

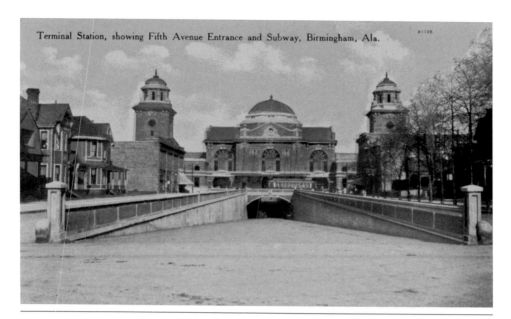

Terminal Station, showing Fifth Avenue Entrance and Subway, Birmingham, Ala.

The Terminal Station was built here in 1909 for all trains except the L&N, seen on the previous page. Passengers exited the trains, and downstairs they boarded streetcars that carried them from the tunnel down Fifth Avenue to the many hotels that had clustered there. By the 1920s, about 100 passenger trains arrived and departed each day. The Terminal Station was another casualty of the Red Mountain Expressway and was demolished in 1969.

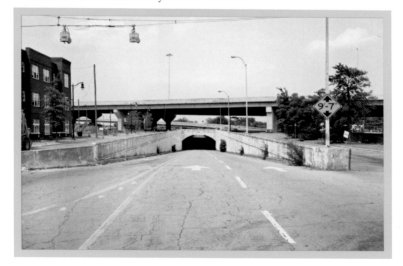

After the election to move the county seat from Elyton to Birmingham, this Jefferson County Courthouse building was constructed in 1873 on the northeast corner of Third Avenue and Twenty-first Street. Less than 15 years later, the building would be deemed unsafe; in 1889, a new courthouse was erected on the same site. In 1931, a new courthouse was built next to Capitol Park, now Linn Park. For many years, this site would be a surface parking lot. The Concord Center Office building was recently constructed there.

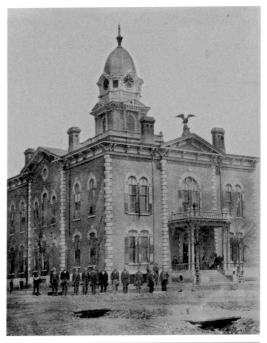

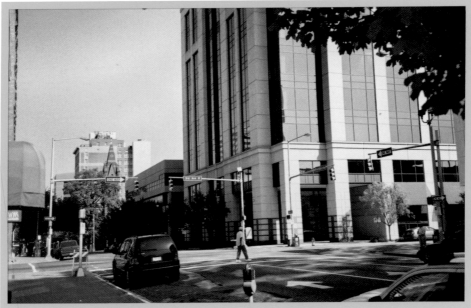

INDUSTRIES, GOVERNMENT FACILITIES, AND OTHERS

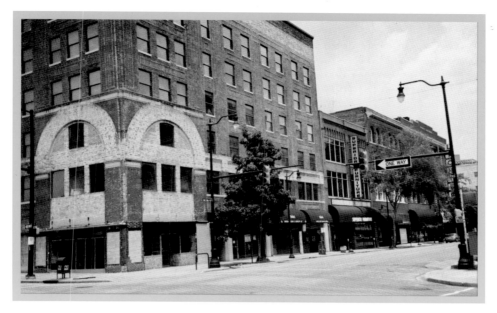

The Iron Horse was playing at the Lyric Theatre in this 1924 view. The Lyric, built in 1914, was located on the northeast corner of Third Avenue and Eighteenth Street. This streetcar advertising the movie has about 70 motormen and conductors in front of the theater. The Lyric was very successful but began to decline in the 1960s. Currently there is a multi-million-dollar project underway to renovate the Lyric for use as a theater again, much like the Alabama Theatre located across the street.

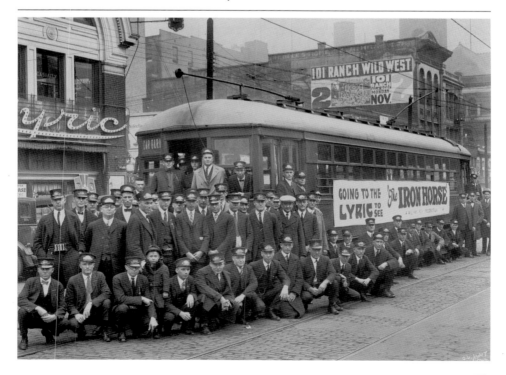

www.arcadiapublishing.com

Discover books about the town where you grew up, the cities where your friends and families live, the town where your parents met, or even that retirement spot you've been dreaming about. Our Web site provides history lovers with exclusive deals, advanced notification about new titles, e-mail alerts of author events, and much more.

Find Your Place in History.